SUMMER MOUNTAINS
The Timeless Landscape

WEN FONG 夏山

SUMMER MOUNTAINS

The Timeless Landscape

The
Metropolitan
Museum of
Art
1975

LIBRARY OF CONGRESS CATALOGING IN PUBLICATION DATA

Fong, Wen.
 Summer mountains.

 1. Hsia-shan-t'u (Scroll). 2. Painting, Chinese—Sung-
Yuan dynasties, 960–1368. 3. Painting, Chinese—Ming-
Manchu (Ch'ing) dynasties, 1368–1912. 4. Landscape in
art. 5. Mountains in art. 6. Paintings—Attribution. I. Title.

ND 1049.6.F66 758'.1'0951 75-23008
ISBN 0-87099-135-3

In memory of M. M. H.

ACKNOWLEDGMENTS

I was assisted by Heather Peters in the preparation of the manuscript. Shen Fu helped me with the map.

W.F.

Why do people love landscape? Hills and gardens restore our nature, so we should visit them often. Springs and rocks are good for carefree rambling, so we delight in them. In landscapes we become fishermen, woodcutters, and hermits—with monkeys, cranes, and birds as our frequent companions.

Kuo Hsi

(active about 1050–90), painter and theorist

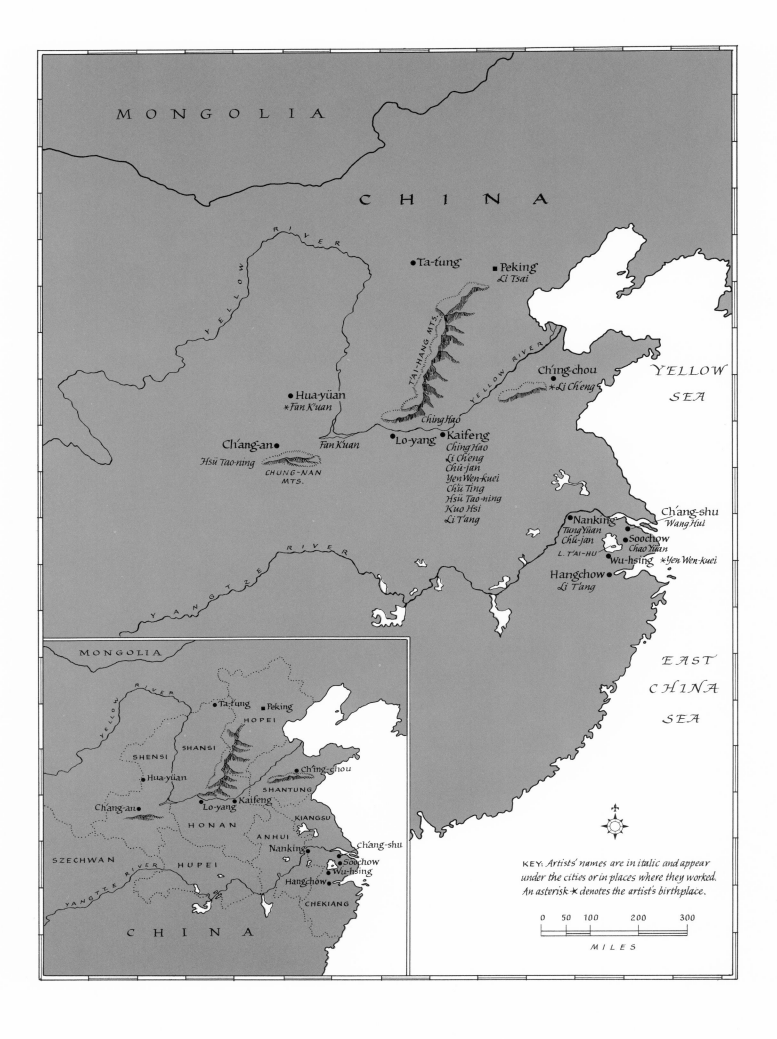

MONGOLIA

CHINA

• Ta-tung ■ Peking
 Li Tsai

YELLOW
SEA

Ch'ing-chou
Li Ch'eng

• Hua-yüan
Fan Kuan

Ching Hao

Ch'ang-an •
Hsü Tao-ning Fan Kuan Lo-yang • • Kaifeng
 Ching Hao
CHUNG-NAN *Li Ch'eng*
MTS. *Chü-jan*
 Yen Wen-kuei
 Chü Ting
 Hsü Tao-ning
 Kuo Hsi
 Li T'ang

 • Nanking Ch'ang-shu
 Tung Yüan *Wang Hui*
 Chü-jan
 • Soochow
 Chao Yüan
 L. T'AI-HU
 • Wu-hsing *Yen Wen-kuei*

 Hangchow •
 Li T'ang

YELLOW RIVER

YANGTZE RIVER

EAST
CHINA
SEA

MONGOLIA

YELLOW RIVER

• Ta-tung ■ Peking
 HOPEI
SHANSI
SHENSI
 Ch'ing-chou •
• Hua-yüan
 SHANTUNG
Ch'ang-an • Lo-yang • • Kaifeng
HONAN
 KIANGSU
SZECHWAN ANHUI
 Nanking • Ch'ang-shu
 HUPEI • Soochow
 • Wu-hsing
 Hangchow •
YANGTZE RIVER
 CHEKIANG

CHINA

KEY: *Artists' names are in italic and appear*
under the cities or in places where they worked.
An asterisk ★ denotes the artist's birthplace.

0 50 100 200 300

MILES

LANDSCAPE has been the dominant subject in Chinese painting ever since it emerged as the pre-eminent art form of the Northern Sung period (960–1127). The recent acquisition by the Metropolitan Museum, as a gift of the Dillon Fund, of a superb large Northern Sung handscroll, *Summer Mountains*, provides the opportunity to consider in some detail the landscape art of this period, together with its antecedents and later permutations.[1]

Developing during the war-filled years of the tenth century, Northern Sung landscape painting produced timeless images that were followed and imitated for centuries. This art reached its apogee in the third quarter of the eleventh century. After the fall of the Northern Sung, it continued to be popular in the north, both under the Chin tartar and then the Mongol rule during the twelfth and thirteenth centuries. Meantime the painters of the Southern Sung (1127–1276), south of the Yangtze River, developed a simplified style that described the softer landscapes of the south.

There were three revivals of the Northern Sung grand manner in landscape painting, the first during the Yüan period (1277–1368), when the Mongols dominated the whole of China, the second in the fifteenth century, after the Ming overthrew the Mongols, the third at the turn of the eighteenth century, in the early Ch'ing (Manchu) period. Although landscape painting during the Yüan period and afterward was essentially different from that of the Northern Sung, it continued to evoke motifs and themes made popular by the Northern Sung masters.

Traditionally attributed to Yen Wen-kuei, a painter active about 980–1010, the Metropolitan Museum's *Summer Mountains* is, instead, a work in Yen's style, probably painted about 1050. But since Yen's style remained influential for centuries, an analysis of the Yen Wen-kuei tradition becomes a capsule account of the development of Chinese landscape painting between 1000 and 1700.

As one attempts to date the many works in the Yen Wen-kuei tradition, it is necessary to keep in mind the following: When a painter works in the manner of an older master, he first adopts the characteristic brushwork idioms, the form elements, and the compositional motifs. But in expanding his interpretation and giving it new articulation, he necessarily deviates from the original and makes subtle changes. In short, the later painter shows in his work not the real earlier master but a transformed image of him. These changes are not "slips of hand" or "misunderstandings"; instead, they are positive signs of the later painter's own style. Even a more or less mechanical copy, which, in the absence of the original work may be historically useful in reconstructing it, inevitably reveals something of its own time.

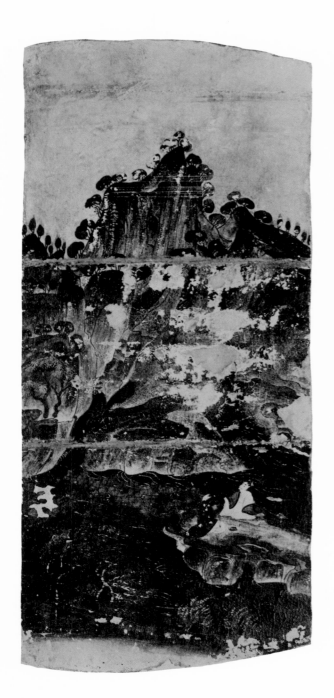

I

LANDSCAPE PAINTING began in China in the late fourth century, when it was part of the nature cult and philosophy of reclusion during the time of disunity and anarchy after the collapse of the Han empire (A.D. 221). The early (pre-T'ang) representations of mountains and trees resemble their ideographic counterparts: *shan* 凸 showing three peaks, a "host" flanked by two "guests," and *mu* 木 describing forking branches above and anchoring roots below. The first important compositional discovery was that overlapping triangles 𝆶 suggest recession. In the late seventh and early eighth centuries (T'ang period) three basic compositional schemes developed. The first is exemplified in *Sitting under a Mountain* (1), a high-mountain conception with towering peaks, a large central one flanked by smaller ones. The composition progresses in three stages: water reeds in the foreground, two seated figures in the middle distance directing their gaze upward, and soaring peaks in the background. *Hawks and Ducks* (2) shows the second scheme, an open panoramic view progressing from front to back in three stages of horizontal elements. *Tiger Hunt* (3) shows the third in its combination of vertical elements at the left and horizontal ones at the right to form a valley scene.

Quite as important to the artist as the type of composition were his methods of modeling the forms. We find the beginnings of

1 *Sitting under a Mountain*

Painting on a biwa (lute)
8th century
Shōsōin Treasury, Nara, Japan

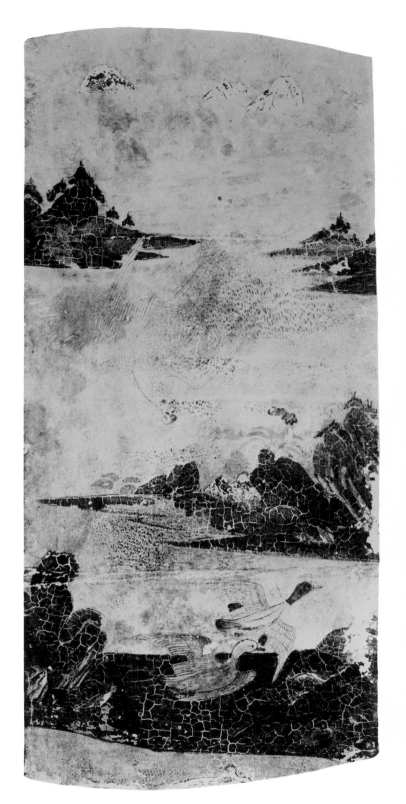

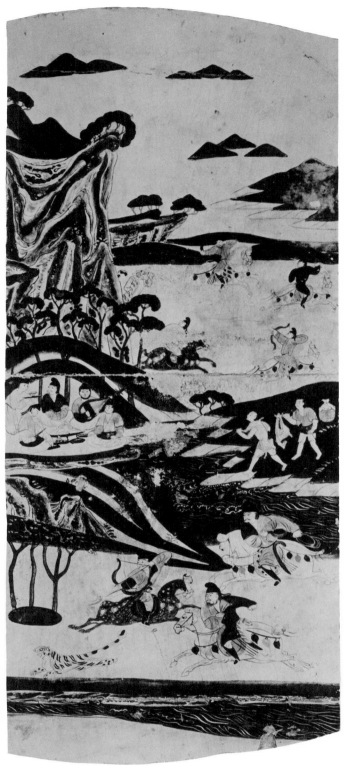

2 *Hawks and Ducks*

Painting on a biwa
8th century
Shōsōin Treasury

3 *Tiger Hunt*

Painting on a biwa
8th century
Shōsōin Treasury

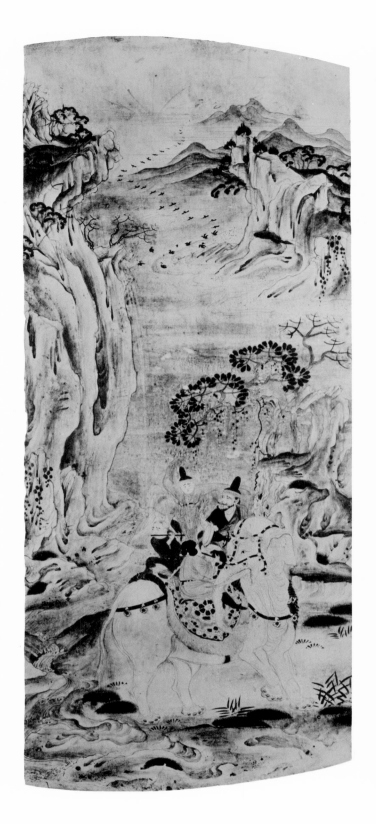

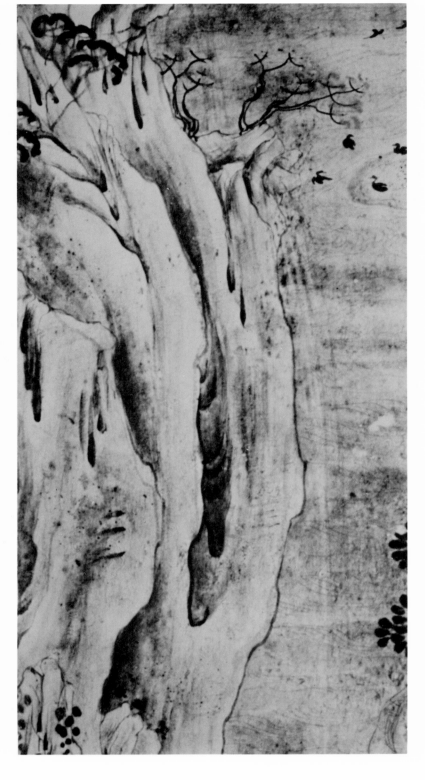

4 *Musicians Riding on an Elephant*

Painting on a biwa
8th century
Shōsōin Treasury

5 Detail of 4

ts'un, or texture patterns, for modeling rocks in another of these early paintings, *Musicians Riding on an Elephant* (4). A graded shading technique is used along with thickening and thinning contour lines, and timid texture strokes begin to appear in the shaded crevices. These softly rubbed, parallel brushstrokes, following as they do the parallel swelling contours of the mountain, may be regarded as prototypical "hemp-fiber" texture strokes (5). A very different kind of rock modeling is seen in *Lady Standing under a Tree* (6) a screen painting of the same period. The rock, an ornamental garden variety from T'ai-hu (Lake T'ai), shows jagged contours, with jagged and stippled texture strokes. The late tenth-century art historian Huang Hsiu-fu noted that early masters, when painting T'ai-hu rocks, merely filled the recessed areas with light or dark ink, but that when Huang Chü-pao painted them, about 990, he "used the tip of his brush in stippling and rubbing motions, making his rocks rich in both ornament and principles. These rocks, with sand and pebbles in their surfaces, have sharp and hard corners. They look like reptiles and tigers

6 *Lady Standing under a Tree*

Screen painting
8th century
Shōsōin Treasury

7 Wintry Forests and Layered Banks

Hanging scroll on silk, attributed to Tung Yüan
Style of about 950
Kurokawa Foundation, Hyogo, Japan

waiting to pounce on something; their shapes and attitudes are not limited to any single kind."[2] The smooth modeling pattern and the jagged one, roughly corresponding to earthen and rocky mountain forms, became in time two opposed landscape idioms.

The period of disunity between T'ang and Sung, known as the Five Dynasties (907–60), was one of the most chaotic in China's history: in fifty-three years there were five changes of "imperial" courts, the longest (Later Liang) lasting seventeen years and the shortest (Later Han) only four. With rulers rising from the common soldiery, all ancient respect for pedigree and social order was swept away. The history of the time is filled with stories of murder, massacre, incest, and debauchery. Northwestern China, especially around Ch'ang-an and Lo-yang, the "twin capitals," which had been for more than a thousand years, through T'ang, the seats of imperial power, was devastated by misrule, heavy taxation, and continuous rebel warfare. After 960 the Sung capital was at Pien-ching (Kaifeng), east of Lo-yang, in the North China plain.

In the grim and inglorious years of the first half of the tenth century, when all forms of art including literature and calligraphy were in decline, landscape painting was the one brilliant contribution to cultural life. It was now that Ching Hao, a Confucian scholar turned hermit and painter after the fall of the T'ang, formulated a coherent theory for landscape. Active about 900–30, and living in retirement in the T'ai-hang mountains in northern Honan, far from political and imperial concerns, Ching rediscovered moral striving and the pursuit of truth in art. Contrary to the Greek view that painting was mimesis, the Chinese view was that the painter's goal was "transmission of the spirit." In his treatise *Pi-fa-chi (Notes on Brush Method)*[3] Ching posed the question "What is likeness, what is truth?," to which he provided this answer, attributing it to a wise old man of the mountains: "A picture of likeness achieves only the physical appearance, but leaves out the life breath of the subject, but in a picture of truth the life breath and inner qualities of the subject are fully present."

This insistence on "truth" is related to the Sung Neo-Confucian investigation of the *li* (principles) and *hsing* (nature) of things. The sage of the *Pi-fa-cha* continues:

> Now that you love to paint clouds and forests, mountains and streams, you must learn to understand the underlying principles of natural objects. When a tree grows, it receives its impetus from its own specific nature . . . though it may curve, it will not bend. . . . Even as a sapling, it stands upright, its budding heart already harboring noble ambitions. Once it grows above all other trees, its lower branches stretch out to protect the others, and its hanging branches seldom fall to the ground. Spreading out thickly in layers in a forest, it seems to possess the virtuous air of an upright gentleman.

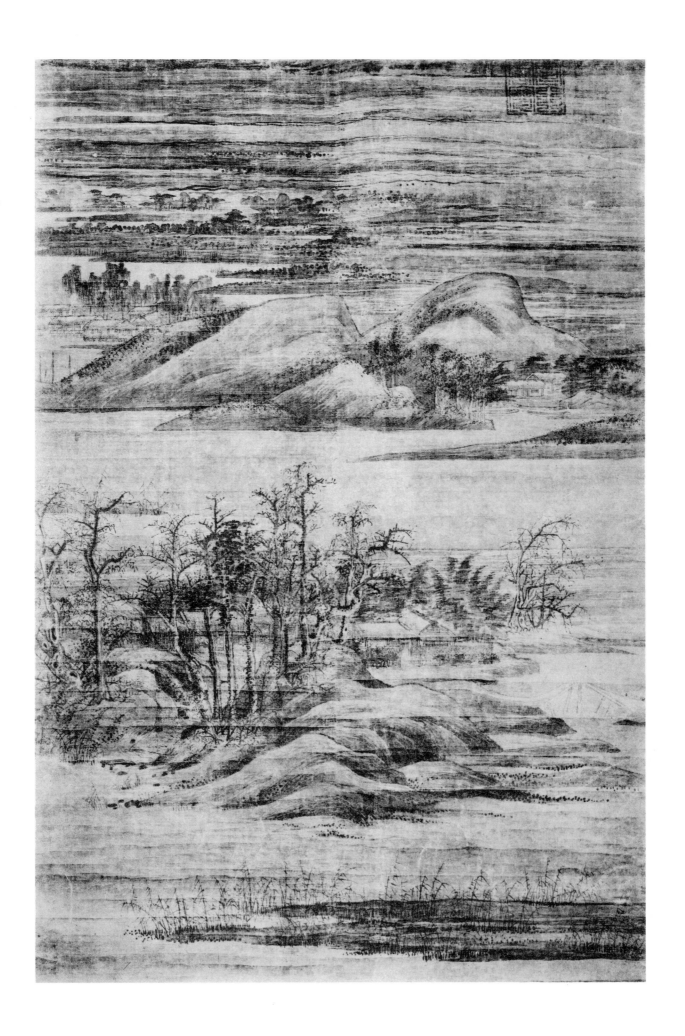

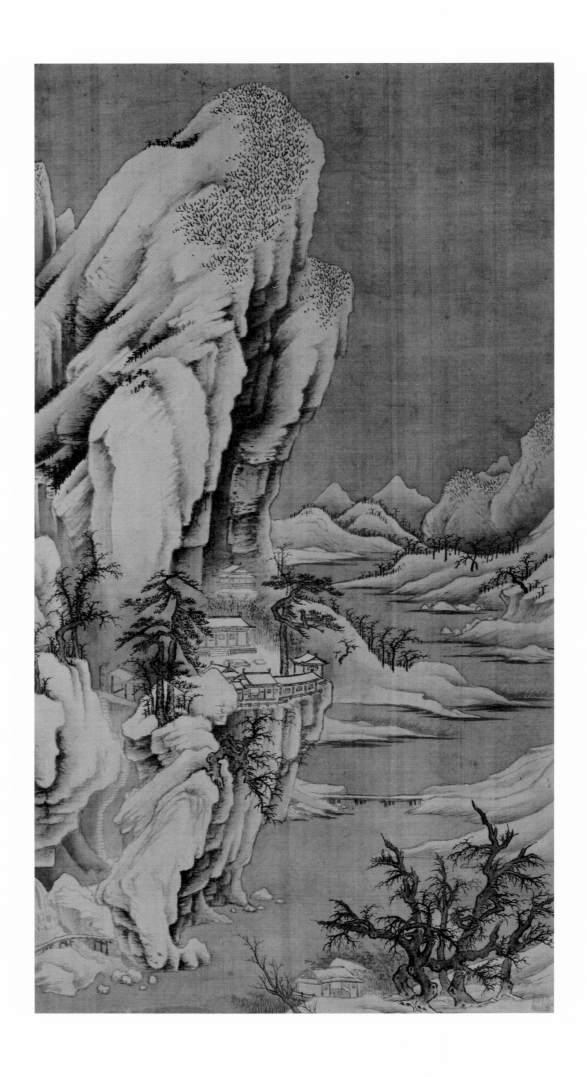

The six essentials for landscape painting, according to the sage, are

Ch'i (life breath):
> As the heart responds and the brush moves forward, forms are seized without hesitation.

Yün (resonance and elegance):
> Where forms are omitted or elaborated upon, the choice is never vulgar.

Ssu (thought):
> By sorting out essentials, the painter conceives the form.

Ching (scenery):
> By observing the laws of nature and the seasons, he searches out the sublime and creates a true landscape.

Pi (brushwork):
> Though following certain basic methods, it must move freely and know how to improvise. It must not be too solid or assume too definite a form; it must look as if in flight and constant motion.

Mo (ink wash):
> High and low peaks are described by a light ink wash, which also makes objects stand out clearly either in shallow or deep recession. The drawing and ink wash are so natural that they do not seem to be made by a brush.

About the time of Ching Hao, landscape painting also flourished in southern China. Tung Yüan, living in Nanking, capital of the prosperous southeastern principality of Southern T'ang (937–76), developed a style suited to depicting the scenery of the south. In *Wintry Forests and Layered Banks* (7), attributed to Tung, the simple triangular mountain forms with parallel folds and the softly rubbed, parallel texture strokes ("hemp-fiber" strokes), seem to hark back to T'ang prototypes of the eighth and ninth centuries. After the reunification of the south in 976, the southern style was brought north to Kaifeng by Tung Yüan's follower Chü-jan, but its influence was not strongly felt in Northern Sung landscape painting until the very end of the eleventh century.

The first great landscape master of the early Northern Sung was Li Ch'eng (919–67). Born in Ch'ing-chou, Shantung, he probably lived and worked in Kaifeng between 956 and 964.[4] A glimpse of his powerful style may be had in an early seventeenth-century copy, *Snow Scene* (8), in which an overhanging precipice on one side is combined with a rolling panoramic view on the other—the third of the T'ang compositional schemes. Because this is a snow scene and also because it is a copy, the convoluted rock outlines, as well as the stippled and jabbed texture strokes, are not as sharp and lively as we might expect them to be in an original work by Li Ch'eng. Even so, the rock and tree forms support the tradition that Li painted rocks like devils' faces and

8 Snow Scene

Album painting on silk, early 17th-century copy after hanging scroll attributed to Li Ch'eng National Central Museum, Taipei, Taiwan, Republic of China

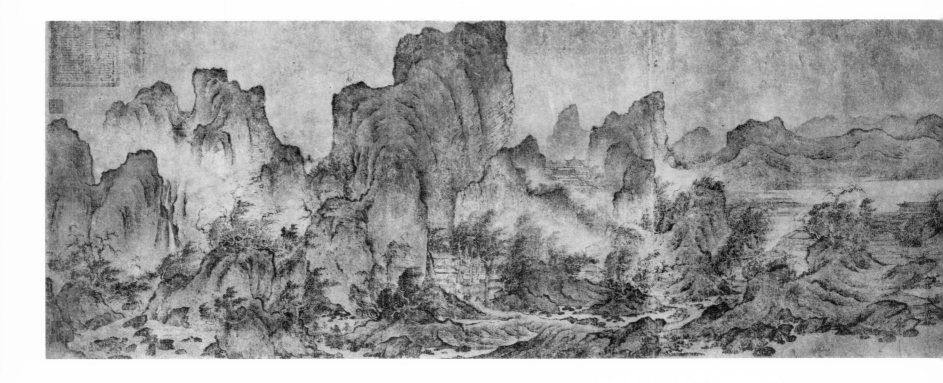

9 Pavilions by Rivers and Mountains

Handscroll on paper by Yen Wen-kuei
About 1000
Abe Collection, Osaka Municipal Museum, Japan

trees like crabs' claws. Li's work was already scarce a century after his death. It is said that because his family descended from the T'ang imperial clan, Li was ashamed of being treated as a mere painter, and that in the Ching-yu years (1034–37), a grandson of Li's, then governor of Kaifeng, bought up all of Li's paintings, presumably in consideration of the painter's wish not to leave them in unworthy hands.

The influence of Li Ch'eng's style was paramount at the turn of the eleventh century. It can be detected clearly in the works of Yen Wen-kuei and the slightly younger master Fan K'uan.

A southerner from Chekiang, Yen Wen-kuei served in the army before going north to Kaifeng in the late 970s. There, his talent was discovered and he was made a member of the imperial Painting Academy.[5] The earliest surviving work attributed to Yen, and the one most likely to be from his brush, is a large hand-scroll on paper, *Pavilions by Rivers and Mountains* (9). Its convoluted mountain contours and eroded surfaces evoke a scene of northern Honan. Yen's modeling strokes are close to Li Ch'eng's; they include loosely applied stipples, broader and less distinct rubbing strokes, and sharp diagonal hatching strokes, the latter on the side of the central peak (10). Technically, the modeling is done in three distinct steps: outline strokes, texture strokes, and graded ink washes. Yen's reputation for exquisite and lively drawing of boats, fishermen, and buildings is well borne out here. The drawing is sensitive, minute, economical, and tactilely descriptive. The graceful movements of the windblown trees, which are present in three or four rhythmically contrasting species, add a vivid sense of atmospheric environment.

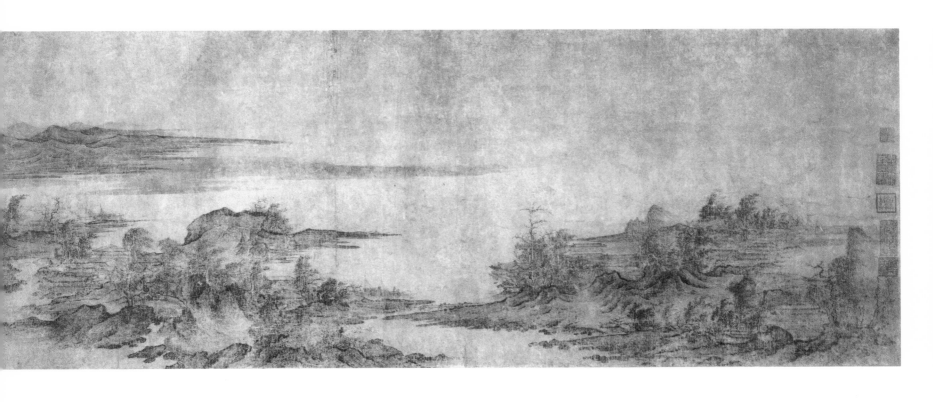

10 Detail of 9

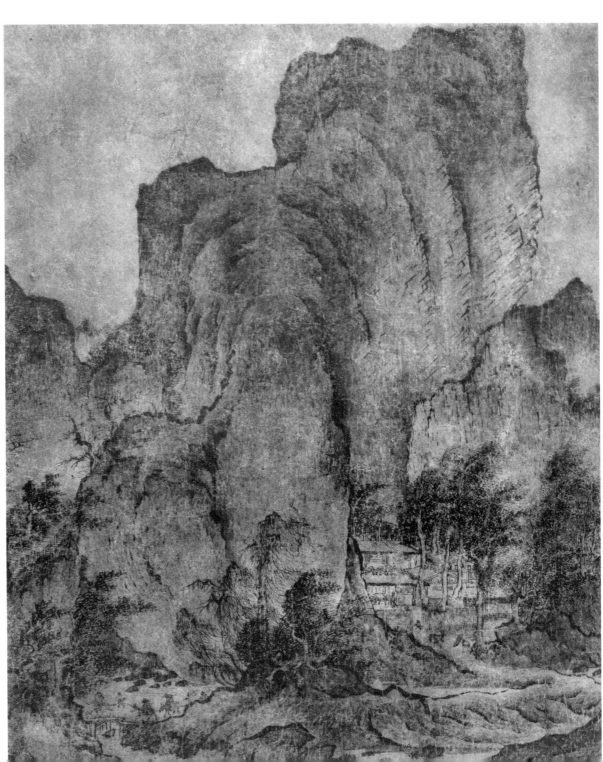

Structurally, the mountain forms are conceived frontally and additively. They move either laterally or vertically, motif by motif, with their lower parts terminating or fading, one by one, into the picture plane. There is no physical integration between the individual motifs. The largest peak, for instance, tries to recede diagonally into space toward the upper left, but since the front of the mountain follows the archaic convention of a series of vertically enveloping triangles, and the right side of the mountain is brought back into the frontal plane, the front and back of the mountain stay in the same lateral plane and the mountain remains a single disparate motif.

Another early Northern Sung master, Fan K'uan (active about 900–1039), a native of Shensi, first painted in Li Cheng's style. Later, declaring that "it is better to study nature, and better still, to follow one's own heart," he retired to the mountains to the west of Honan and developed his own syle. According to the late Northern Sung imperial catalogue, *Hsüan-ho hua-p'u*, Fan

> lived among the crags and coves and wooded hills in the Chung-nan and T'ai-hang mountain ranges, daily observing the clouds, mist, melancholic ways of wind and moon, and the indescribable effects of the darkening and clearing skies. Silently his spirit communicated with them. . . . Such were his thousand cliffs and ten thousand gorges that they instantly made one feel as if walking along one of those shaded mountain paths, and even in the middle of summer, one felt chilled and wished to be bundled up in a cover. Thus it was said that K'uan was able to transmit the spirit of the mountains.[6]

11 *Travelers among Streams and Mountains*

Hanging scroll on silk by Fan K'uan
About 1000
National Palace Museum, Taiwan,
 Republic of China

In Fan's *Travelers among Streams and Mountains* (11) the mountain form vividly captures the geological peculiarities of southern Shensi and northwestern Honan, where almost everywhere the steep-sided cliffs, valleys, and gullies are blanketed by thick layers of fine-grained, wind-deposited soil, and, because of this soil, thick vegetation grows at the very tops of the mountains. Fan's mountains, each a generalized triangular form with parallel enveloping folds, are conceived frontally and additively, yet the depiction, with its nervously charged contours, deep crevices, and pointillistic texture dots describing the gritty, soil-covered surfaces, conveys a powerful and immediate sense of tactile realism that epitomizes the new landscape vision of the early Northern Sung period. Fan's mountain modeling, like Yen's, is accomplished in three steps: first, incisive thickening and thinning outline strokes, followed by innumerable stippled strokes of varying shapes and sizes, and, finally, a filling in and rounding out with a graded ink wash. It is possible to see stylistic affinities between the work of Fan K'uan and Li Ch'eng—the vigorously incisive mountain outlines, gnarled tree forms, vegetation motifs on the mountaintop—but the stippled technique, the so-called "raindrop" dot, seems to be Fan's own invention.

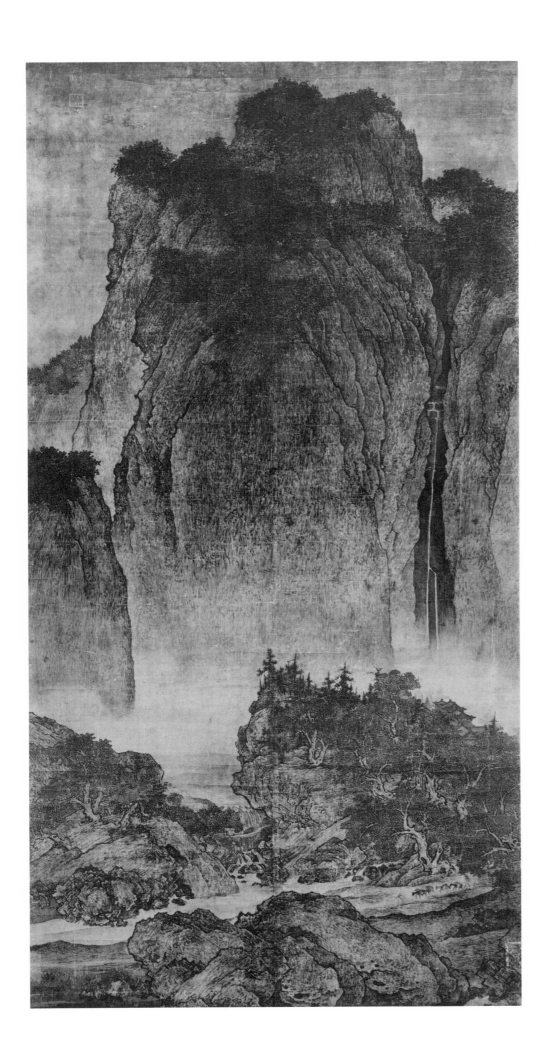

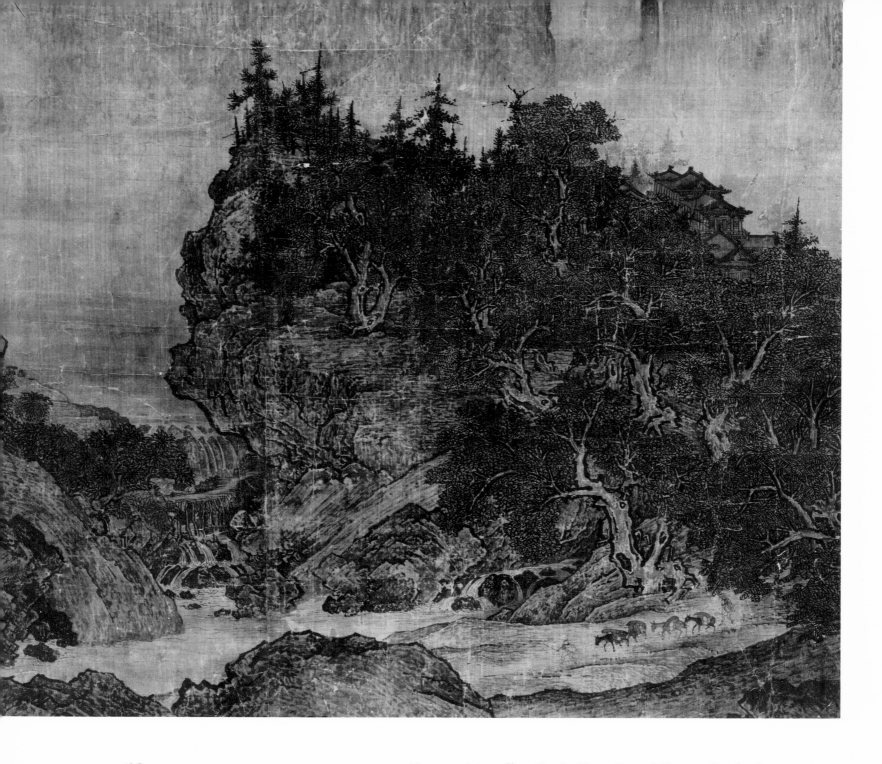

12 Detail of 11

Compositionally, Fan's *Travelers* follows the high-mountain scheme seen in the early *Sitting under a Mountain:* Fan's painting is also divided into three stages, with the foreground and middle elements occupying only a little over a third, and the massive precipices taking up the greater part of the composition. The grandeur of the mountains and forests is accentuated by the tininess of the human figures. At the lower right two men drive a band of laden mules down a path behind two great boulders, a scene typical of northern China (12). Above and behind them, the hill is covered with giant hardwood trees; firs and temple roofs are silhouetted along its upper edge. Beyond the hill the great central peak, flanked by two smaller ones, rises from a mist-filled ravine. The ink wash has a blue gray tone; subdued touches of color are used in the tree foliage. Although the painting is grand and awesome—it is nearly seven feet in height—the drawing is

simple. Its directness of means and expression was said to reflect Fan K'uan's open and rustic nature.

Summer Mountains (13), though traditionally attributed to Yen Wen-kuei, resembles his *Pavilions by Rivers and Mountains* only in general subject matter and composition: in both modeling and the drawing of tree and foliage patterns it has departed from Yen's forms. Calmer in mood, the painting is, in some ways, even more resplendent than Yen's and Fan's. The very air of this summer scenery seems to breathe a well-endowed contentment; the restless energies of the earlier paintings seem to have subsided. The mountain's modeling consists of straight, parallel brushstrokes that blend into the ink washes; the hardwood forests show mostly gnarled white trunks against loosely applied round foliage dots, and these dots, through their varied size and tonality, effectively suggest the merging forms and movements of individual trees. The brushwork seems to show a mixture of influences of the earlier masters, Yen Wen-kuei and Fan K'uan and possibly also Tung Yüan, but there is no hint of any knowledge of the important painters of the second half of the eleventh century. These indications suggest the dating of *Summer Mountains* to about 1050.

The brushwork is generally broader and looser than either Yen's or Fan's (14). Instead of the three distinct technical steps of continuous and complete contour lines, incisively descriptive texture strokes, and graded ink washes, as seen in the earlier works, the freer and broken contours and modeling strokes now merge and blend with ink washes to suggest, rather than describe tactilely, the sense of volume and texture of the forms in space. This concern for volume and space appears to be a conscious choice; even the

13 *Summer Mountains*

Handscroll on silk formerly attributed to Yen Wen-kuei, now reattributed to Ch'ü Ting
About 1050
The Metropolitan Museum of Art

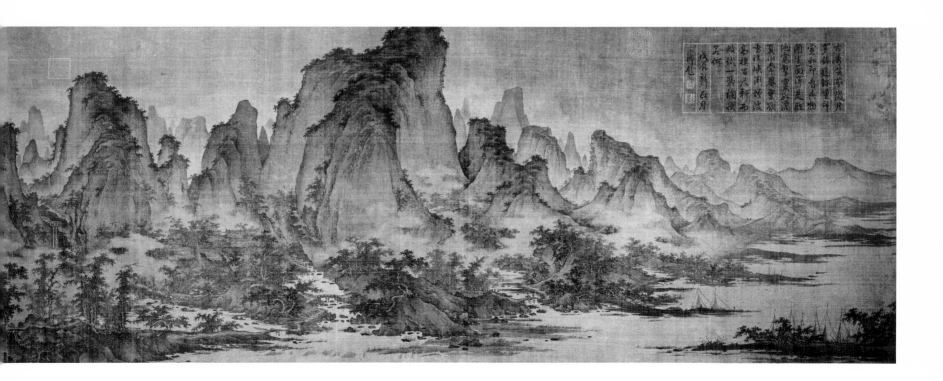

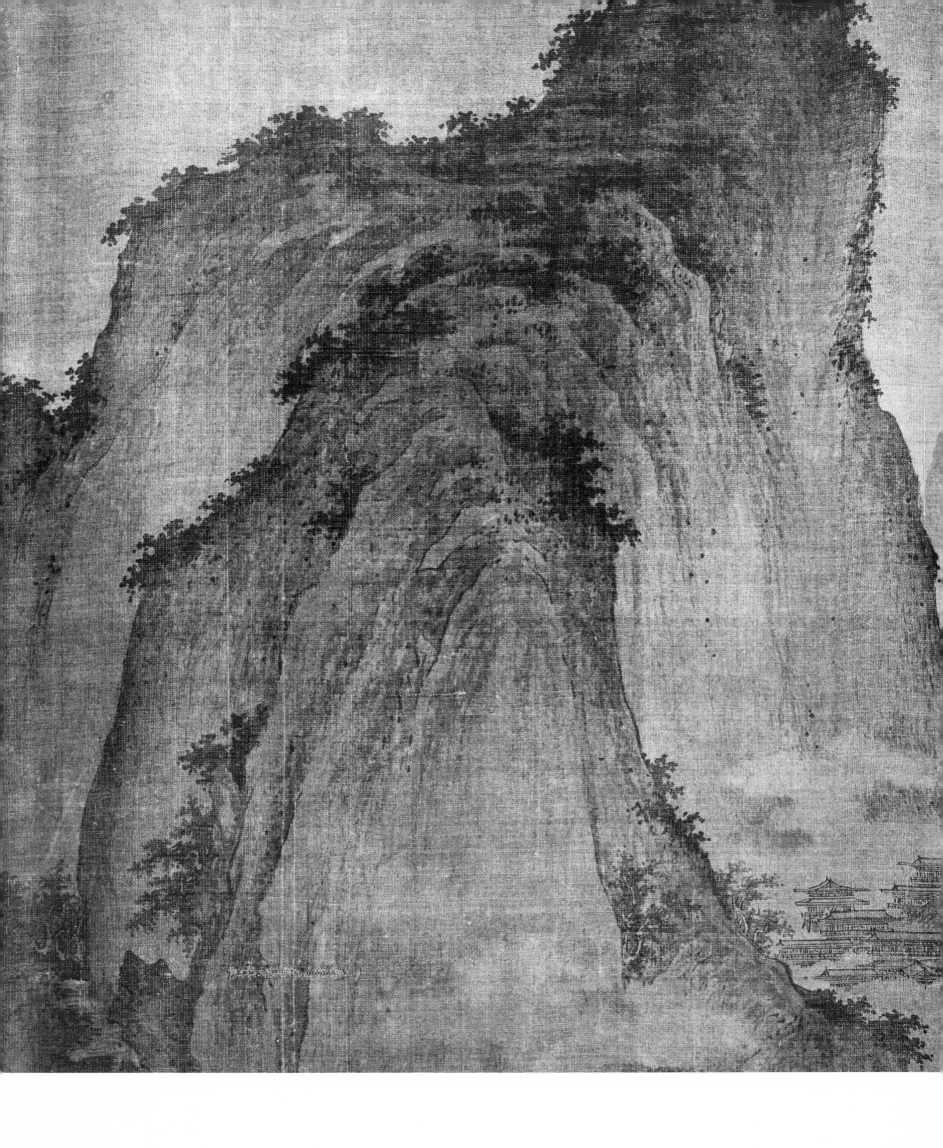

mountains trailing off toward the right are carefully modeled to suggest movement into space. Receding mountain ranges are built with overlapping triangular motifs, sometimes one single mountain form showing a twisting "spine" branching into two directions (15). Interestingly, this new complexity of form is limited only to the mountaintops; the bases are allowed to fade into blank spaces of mist or water, thus avoiding the problem of a fully described receding ground plane. Although the composition shows a greater sense of spatial unity than both Yen's and Fan's, it remains additive. The mountain forms seem to float in the picture space. They read from right to left, and front to back, in a part-by-part, sequential manner.

Elsewhere I have suggested reattributing *Summer Mountains* to Ch'ü Ting, a painter active in Kaifeng about 1023–56.[7] Ch'ü was said to "excel in the depiction of mountain gorges and valleys, with views of twisting and winding forms"[8]—a description that fits *Summer Mountains*.

14, 15 Details of 13

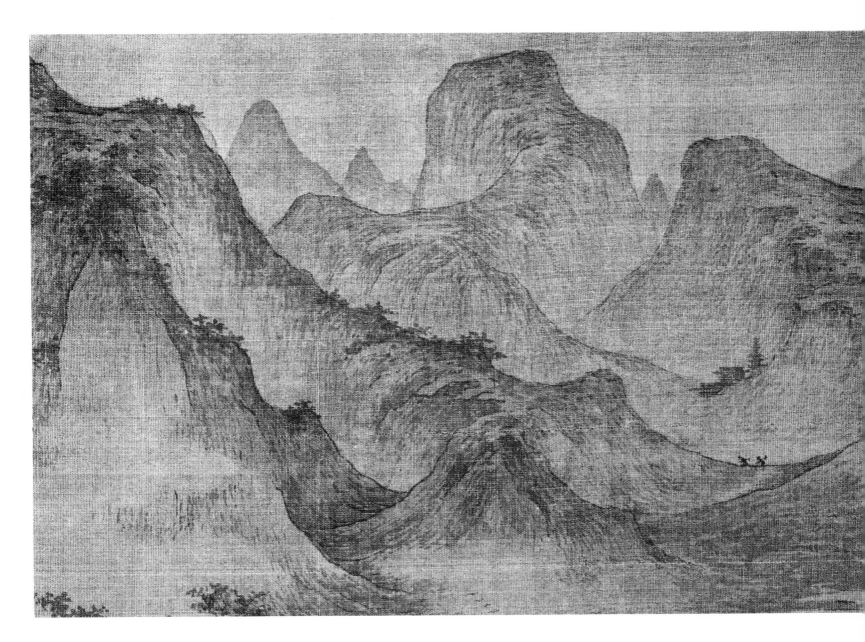

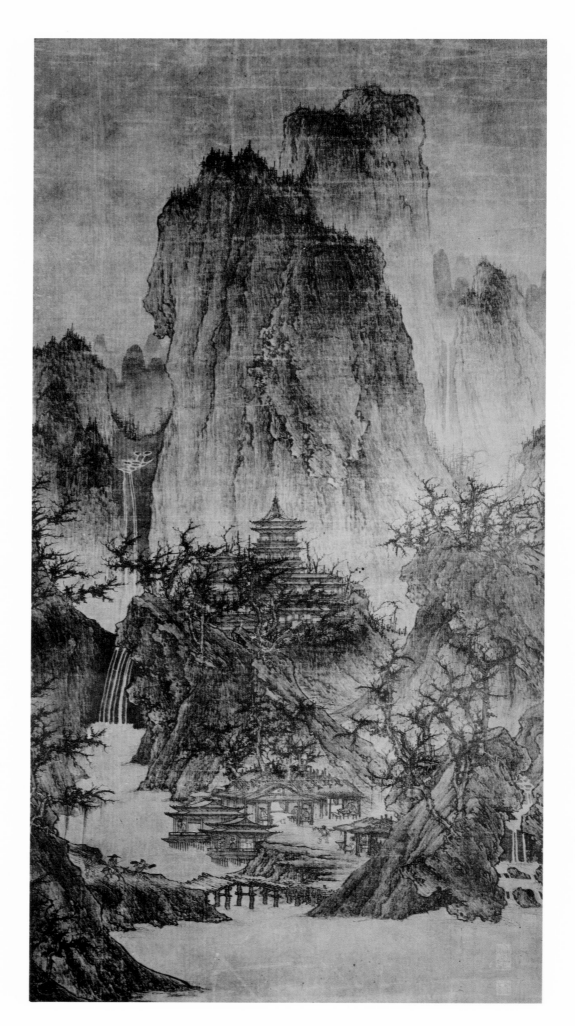

16 *Temple in the Hills*
after Rain

Hanging scroll on silk
attributed to Li Ch'eng
About 1050
Nelson-Atkins Gallery of Art,
Kansas City

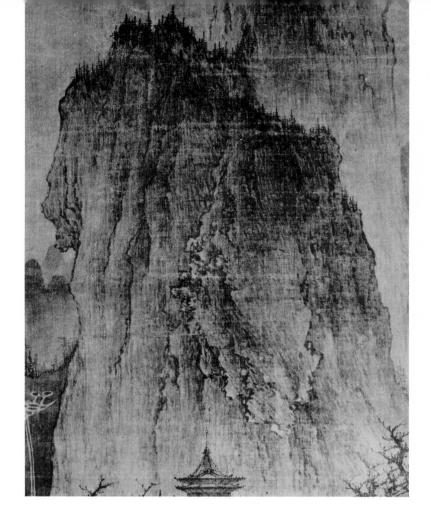
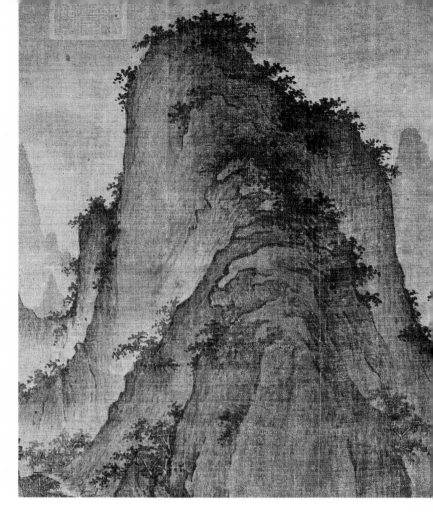

A work that closely parallels *Summer Mountains* in formal structure, and thus suggests a similar date even though it has been attributed to the earliest Northern Sung master, Li Ch'eng, is *Temple in the Hills after Rain* (16). Even more than in *Summer Mountains*, the broken contour lines fuse with the texture strokes and ink washes to give the mountain a sense of three-dimensionality (17, 18). The waterfall to the left is similar to the waterfall at the left of *Summer Mountains* (19, 20). In both paintings the overlapping mountains on two sides create a gap with a series of inverted arches from which streams of water gather and fall, and above which a reverse series of overlapping distant peaks, all in graded ink washes, diminish and fade into the distance. By contrast, the waterfalls in Yen's and Fan's paintings are simple two-dimensional patterns (21).

17 Detail of 16

18 Detail of 13

19 Detail of 16

20 Detail of 13

21 Detail of 9

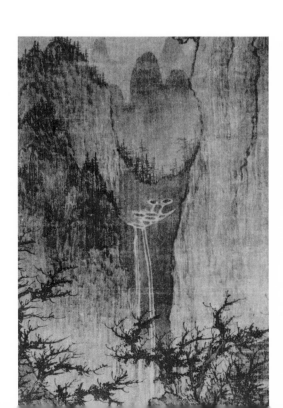
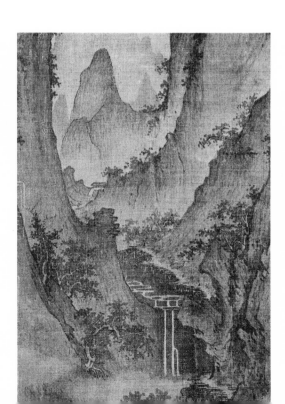
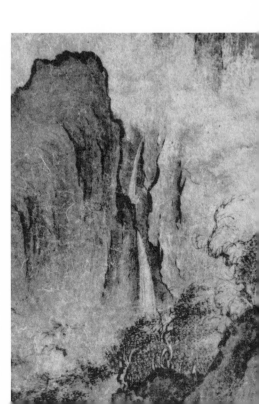

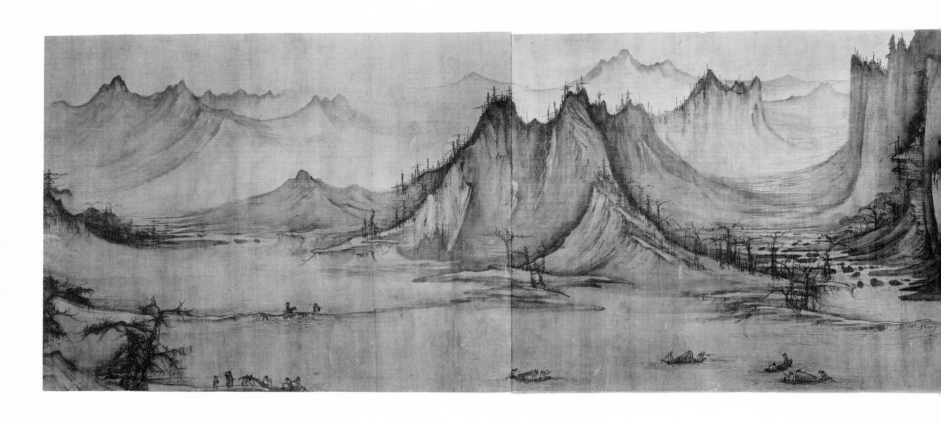

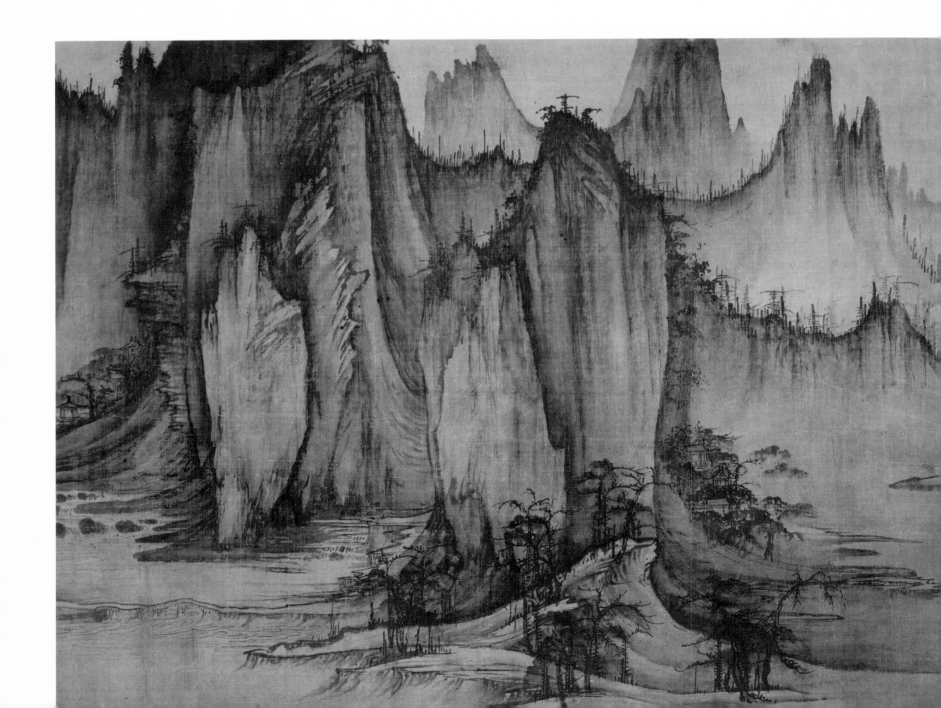

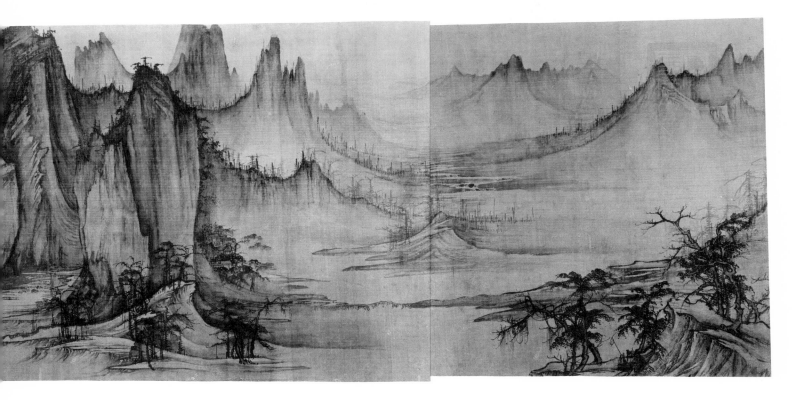

The technical developments in *Summer Mountains* and *Temple in the Hills* provide a convincing basis for the dramatic innovations of Hsü Tao-ning (active about 1030–67 and, according to one eleventh-century source, a pupil of Ch'ü Ting) and Kuo Hsi (active about 1050–90).

Kuo Jo-hsü, an eleventh-century historian of art, remarked that "early in his career Hsü Tao-ning worked with meticulous precision, but as an old man he cared only for simplicity and swiftness of drawing."[9] A large handscroll, *Fishing Boats on the Autumn River* (22), may well be a late work by Hsü, about 1065, after he had freed himself from the restrictive influence of his teacher.

As in *Summer Mountains*, the concern for suggesting volume and spatial recession dominates Hsü's composition, but the techniques of the earlier painting have been expanded. Texture strokes, as they did in *Summer Mountains*, "go straight down from the peaks," (23) but here they are blended with mottled outlines and ink washes into a single complex brush technique that seems to wrestle visions of landscape forms from the silk surface (24). The knifelike peaks and huge canyons have almost the look of lunar scenery. Structurally, the spatial recession in this painting is still accomplished simply by overlapping triangular forms without a fully described receding ground plane. The resultant feeling of forms floating in space only heightens the sense of unreality in this fantastic landscape of the mind.

22 *Fishing Boats on the Autumn River*

Handscroll on silk possibly by Hsü Tao-ning
About 1065
Nelson-Atkins Gallery of Art, Kansas City

23 Detail of 22

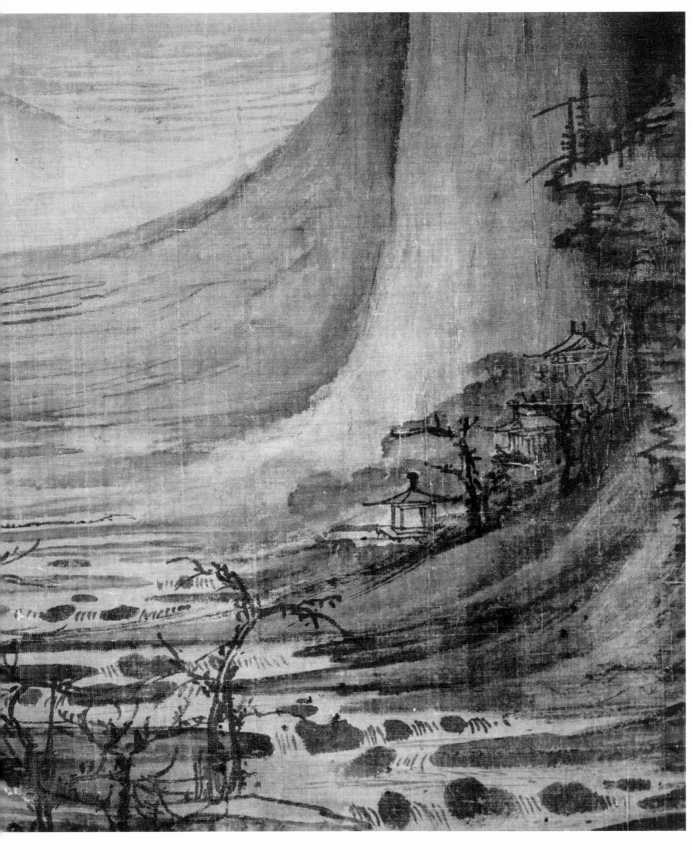

24　Detail of 22

II

By THE SECOND HALF of the eleventh century, landscape painting, now no longer a hermit's pastime only, enjoyed a broad base of appreciation in the Northern Sung, from the scholar-official elite and the more affluent merchant class alike. Continuing to uphold eremitism as a pure way of life, the Chinese argued that it was possible to be a "hermit at court" or even a "hermit at the marketplace." What mattered ultimately was a pure state of mind. Kuo Hsi, the leading landscape painter and theorist of his time, called it "the heart of forests and streams." In his *Lin-ch'üan kao-chih (Lofty Ambitions in Forests and Streams)*,[10] Kuo asked:

> Are we to say that a benevolent man must always step away from life and journey into the other world, and thereby compete in purity with some virtuous hermits? . . .
>
> How delightful then to have a landscape painting rendered by some skillful hand! Without leaving the room, a person may find himself sitting among streams and ravines; the cries of the monkeys and birds faintly reach his ears, light on the hills and reflection on the water, glittering, dazzle his eyes. Is this not "to make others happy will satisfy my own desire?"

For Kuo Hsi the secret of being a painter—and understanding painting—lay in *chin*, a serious and respectful attitude. "In order to grasp Creation, nothing is more divine than love for the subject," he said; "nothing enables one to concentrate better than diligent study, and nothing is grander than to wander about and satiate one's eyes with landscape scenery." He expanded on these in the language of a Sung Confucian scholar:

> In depicting scenery . . . a painter must be severe and serious in his work in order to give it dignity; if he is not severe his thoughts will not be profound. He must be diligent and respectful in order to make his work complete; without respectfulness, the scenery will not be complete.

It was Kuo who formulated landscape into the two contrasting modes, earthen and rocky:

> Some mountains are covered with earth, others are covered with stones. On earthen mountains that are covered with stones, the forest growths and trees are lean and tall; on rocky mountains that are covered with earth, the forest growths and trees are fat and luxuriant.

According to these definitions Tung Yüan's *Wintry Forests and Layered Banks* is in the earthen mode while Fan K'uan's *Travelers among Streams and Mountains* is in the rocky mode. For landscape composition, Kuo Hsi described three kinds of view:

> From the bottom of the mountain looking up toward the top, this is called the "high distance." From the front of the mountain peering into the back of the mountain, this is called the "deep distance." From a nearby mountain looking past distant mountains, this is called the "flat distance."

The three schemes found in the early T'ang landscapes make Kuo Hsi's meanings clear. Among the compositions so far discussed, Fan K'uan's *Travelers* is a "high-distance" view, Li Ch'eng's *Snow Scene* is a "deep-distance" view, and Tung Yüan's *Wintry Forests* is a "flat-distance" view. All of these are vertical hanging scrolls. Handscroll compositions, even though they are horizontal in format, make use of these basic schemes too.

Kuo saw the "host and guest" relationship as one that reinforced the Sung Neo-Confucian order of the world:

> In painting landscapes one should first attend to the great mountain which is called the host peak. Once the host peak is fixed, one may proceed with the secondary mountains near and far, large and small. It dominates the whole region, that is why it is called the host peak. It is like a ruler among his subjects, a master among servants.

In a restatement of the earlier canon of proportions attributed to Wang Wei (699–759), of "mountains in scores of feet, trees in feet, human figures in fractions of an inch," Kuo wrote:

> In landscape painting there are three degrees of magnitude: a mountain is larger than a tree, a tree is larger than a human figure. If the mountains in a painting are not stacked up by the scores, and if they are shown no larger than the trees, then these mountains are not large. If the trees in a painting are not piled up by scores of layers, and if they are shown no larger than the human figure, then these trees are not large.

25 *Early Spring*

Hanging scroll on silk by Kuo Hsi
Dated 1072
National Palace Museum, Taiwan

Fan K'uan's *Travelers among Streams and Mountains* offers a perfect example of how the sense of vastness may be dramatized through the use of this leaping scale: Lilliputian figures are seen against enormous trees, and both are placed under peaks of cosmic proportions. Blank intervals of space are used not only to prepare the eye for such contrasts, but also to leave much to the imagination.

> If one wishes to make a mountain appear high [Kuo Hsi wrote], one should not paint every part of it or it will not seem high. When mist and haze encircle its waist, then it looks tall. If one wishes to paint a stream stretching afar, one should not paint its entire course, or it will not seem long. When its course is shadowed and interrupted, then it seems long.

On another point Kuo said:

> Mountains viewed at a close range have one appearance; viewed from a distance of several miles, another, and viewed from a distance of scores of miles, still another. Every time one moves away, one gets a different view. This is why it is said that the mountain forms change with every step one takes.

In Fan K'uan's *Travelers*, for instance, the three parts of the composition, moving from the bottom to the top, represent in fact, three separate views of landscape, the near, the middle, and the far. Conceived and mastered separately, these different views

and experiences of the painter add richness and variety to the whole. The viewer, reading the painting part by part, motif by motif, re-experiences it not as a mere retinal impression of nature, but as a total and true landscape.

Kuo Hsi's own masterpiece, *Early Spring* (25), dated 1072, embodies the ultimate grand manner of Northern Sung landscape art. Although Kuo had complained that "nowadays students of Ch'i and Lu [Shantung] imitate only Li Ch'eng, while those of Kuan and Shen [Shensi] imitate only Fan K'uan," Kuo was himself considered the pre-eminent follower of, and innovator in, the Li Ch'eng tradition. In *Early Spring* the brush technique and use of ink are rich, almost extravagant, where Fan K'uan's and Li Ch'eng's had been severe and sparing. The glory of this painting lies in the dramatic interpenetration of its solids and voids: landscape forms now simultaneously emerge from, and recede behind, dense, wafting mists (26). In depicting the mountain forms, Kuo Hsi's outlines, texture strokes, and modeling ink washes are fused into a single technique: thickening and thinning brushstrokes, in ink tones ranging from transparent blue gray to charcoal black, are applied simultaneously so that the different tones of ink run

26 Detail of 25

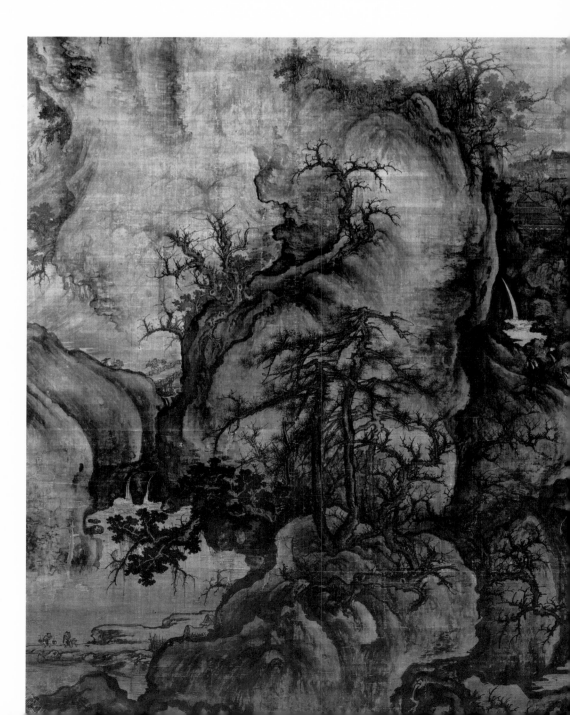

into each other to create a visual impression of wet, blurry surfaces. Kuo stated that he built his forms with many layers of strokes and washes:

> After the outlines are made clear by dark ink strokes, use ink wash mixed with blue to retrace these outlines repeatedly, so that even if the ink outlines are clear, they appear always as if they had just come out of the mist and dew.

Also new in Chinese painting was the suggestion of light in *Early Spring*. On this subject Kuo wrote:

> Mountains on which no distinction is made between bright and shaded parts are known as "deficient in sunlight"; those that do not disappear and reappear are called "deficient in mist and haze." Now the portions of a mountain on which the sun shines are bright, while the other portions where the sun does not fall are dark—such is the normal form of a mountain under sunlight.

A complex painting, *Early Spring* suggests great depth in several parts of its composition (27)—in Kuo's words, "the mountain forms change with every step one takes"—yet at the same time the artist has united the different parts of the painting into a rhythmically flowing whole. The cloudlike mountains seem to

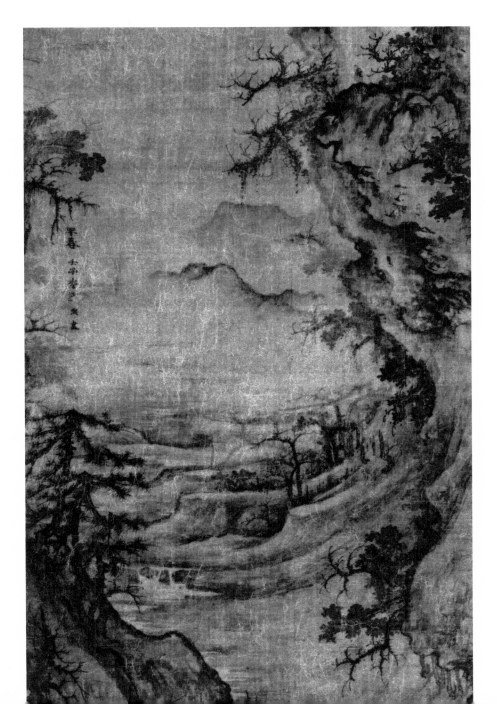

27 Detail of 25

28 *Clearing Autumn Sky over Streams and Mountains*

Handscroll on silk by follower of Kuo Hsi
About 1100
Freer Gallery of Art, Washington, D.C.
(photo: Courtesy of the Smithsonian
 Institution, Freer Gallery of Art)

float in the picture plane; the writhing and turning peaks appear and reappear behind a veil of mist without revealing their bases. As in *Summer Mountains* and *Fishing Boats*, spatial recession in *Early Spring* is suggested, not physically described. Writing of the configurations of mountains and waters, Kuo remarked

> A mountain has watercourses as its arteries, grass and trees its hair, mist and clouds its complexion. . . . Waters have the mountains as their face, pavilions and kiosks as their eyebrows and eyes, and fishing and angling to give them animation.

Although the mountain form in *Early Spring* shows some structural ambiguities, particularly in its mid-area, where it is artfully concealed by mists, the painting is a powerful expression of the belief in landscape as a living being that embodies nature's primordial forces.[11]

Although *Clearing Autumn Sky over Streams and Mountains* (28) has been attributed to Kuo Hsi, this handscroll is probably the work of a close follower, dating around 1100. After *Early Spring*, the mountain forms seem spongy; whereas in Kuo's work the centers of the forms bulge and the contours blur and recede, the contours here are emphasized by a modeling that produces a nearly flat, evenly graded surface (29). Compositionally, the pine trees in the foreground occupy more than half the height of the picture; as a result, the mountain peaks seem very much reduced, a feature increasingly seen in paintings of the early twelfth century. Something new in *Clearing Autumn Sky* is the feeling of intimacy and personal relationship between the human figures and their surroundings. The figures are relatively large in size, and the nature which they see around them seems immediately graspable from where they stand. There is also a strong emphasis on spatial continuity, both laterally and in depth. Distant mountain silhouettes and sandbanks are linked together and stretched out into horizontal bands of ink washes that show clear edges on

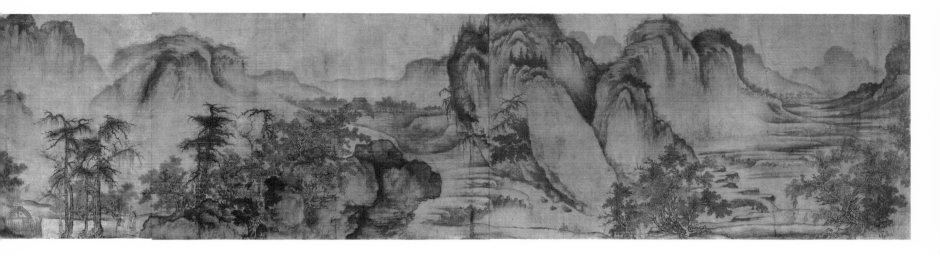

top but fade out at the bottom. These are repeated layer upon layer, suggesting continuous recession even though there is no physically integrated ground plane.

The most dynamic phase of Northern Sung landscape painting ended with Kuo Hsi's death in the late 1080s. While scholar-critics, as learned amateurs, raised increasingly harsh voices against professional painting, a new spirit of retrospection and introspection dominated late eleventh-century landscape painting. Noblemen, scholars, collectors, and painters all learned the art from studying ancient models. The leading Academy landscapist at the end of the Northern and beginning of the Southern Sung was Li T'ang (about 1050–1130), who, like Kuo Hsi, was a native of Honan. In the narrative handscroll attributed to Li,

29 Detail of 28

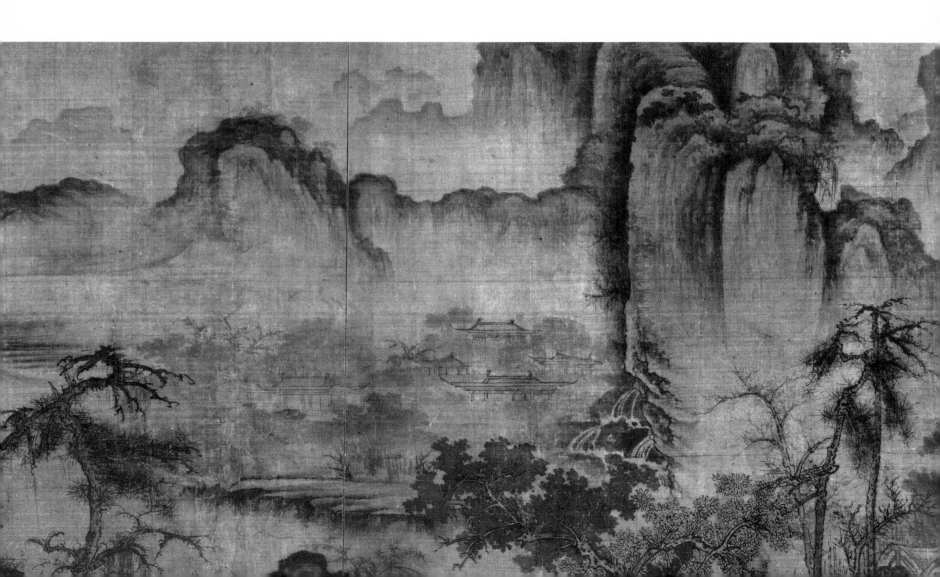

30 *Wind in the Pines of Ten Thousand Valleys*

Hanging scroll on silk by Li T'ang
Dated 1124
National Palace Museum, Taiwan

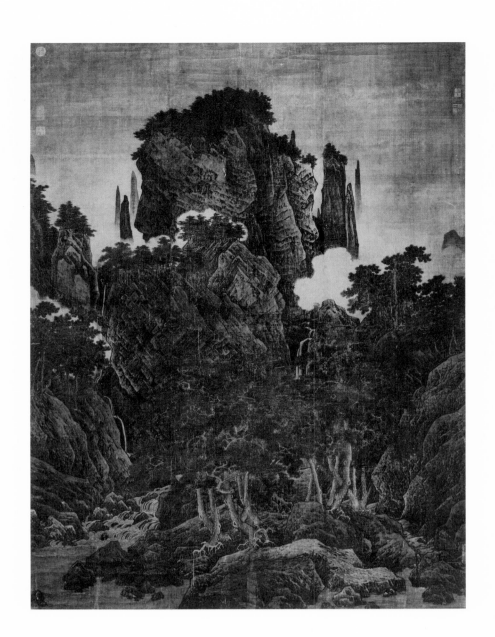

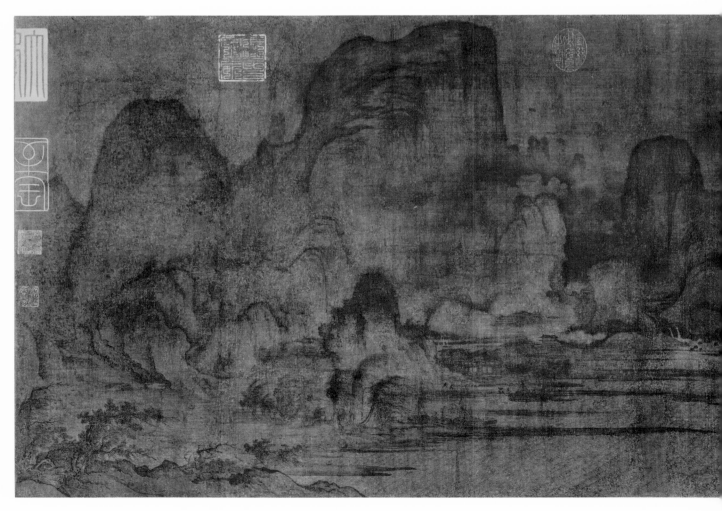

Marquis Wen-kung of Chin Recovering His State, in the Metropolitan Museum, the rock forms clearly follow Kuo's idiom. However, in his large hanging scroll *Wind in the Pines of Ten Thousand Valleys* (30), dated 1124, Li turned back to Fan K'uan as a model, developing that master's stippled texture dots into broader hatching strokes, known as the "small ax." Li's return to a more tactile technique and a clearer mountain structure seems to be a deliberate archaistic reaction to Kuo Hsi's exuberance. A further point: *Wind in the Pines* is the first major instance of tall foreground trees appearing in a "high-distance" composition. In earlier Northern Sung paintings large foreground trees were used only in panoramic, "level-distance" views. Replacing the incredible grandeur of the earlier Northern Sung mountains with a more limited view, somber and restrained, this work of Li's prefigures the more intimate landscape of the Southern Sung.

A handscroll traditionally attributed to Yen Wen-kuei, *Wind-swept Stream* (31) should be dated about the same time as *Clearing Autumn Sky*—that is, around 1100. It is mildew-damaged and dark, but the drawing still shows its exquisite quality. The scene is described with great lyrical feeling: wind-bent trees, finely rippled water surface, billowing sail of a lone skiff, and bursts of clouds between faraway peaks. In its mountain and tree forms as well as its overall composition *Wind-swept Stream* follows Yen's *Pavilions by Rivers and Mountains*, except that here the near and distant mountains are compressed together and pushed back in space to form a visually unified structure that rises and falls along a continuous horizontal line across the picture plane. The moun-

31 *Wind-swept Stream*

Handscroll on silk in the style of Yen Wen-kuei
Around 1100
Formerly Ch'eng Ch'i collection, Tokyo

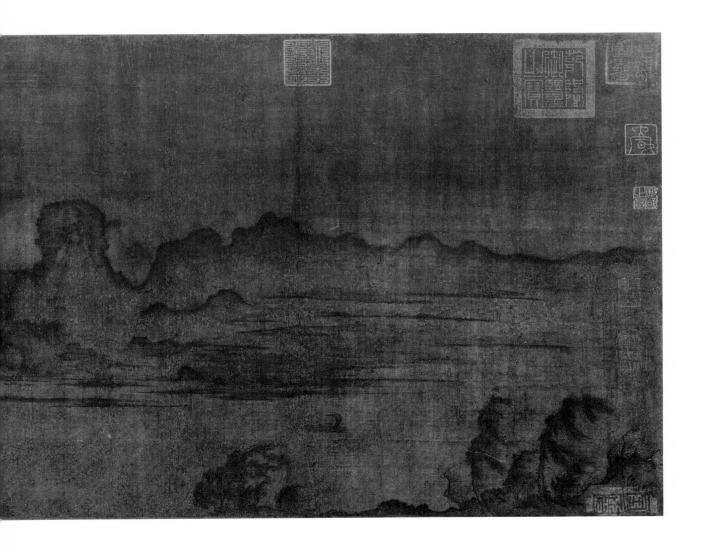

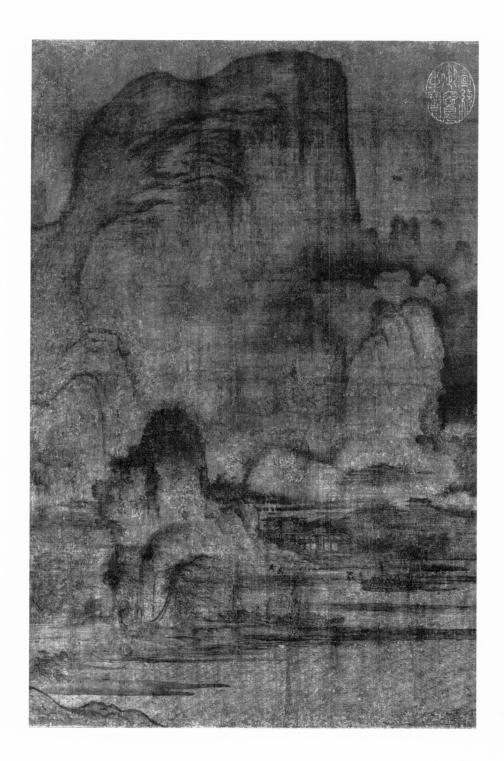

32 Detail of 31

tain modeling is also greatly simplified, with the contours em-
phasized and with graded ink washes playing a larger role than
texture strokes (32). In the vista at the right, the overlapping diag-
onal mountain motifs of the earlier paintings have now become
layers of horizontally undulating silhouettes. This simplification
of form of merging several mountaintops into one laterally con-
nected silhouette is a device shared by several notable works of
this period.[12]

Whereas *Summer Mountains* was the work of an immediate
follower who developed and expanded the Yen manner, *Wind-
swept Stream*, as a later attempt to revive a tradition, nearly a

century after Yen, shows a more conscientious effort to preserve Yen's formal motifs. While the introspective mood of *Wind-swept Stream*, with its compressed mountain forms and simplified modeling, seems to be typical of landscape painting at the end of the Northern Sung, around 1100, the painter has carefully added the minute and precisely drawn details of trees, buildings, tiny figures, and water patterns that were essential features of Yen's manner. The result is a profoundly nostalgic work.

Yet another work in Yen's style can be dated stylistically to about 1100: a short handscroll on paper, *Market Village by the River* (33). Its themes are those for which Yen was famous: a large boat sails toward shore, where others are moored, while on shore people arrive and depart, a young man on his knees bids farewell to an elder, two men eat in a restaurant, and in the distance, laden camels and their drivers head toward the northern steppes.[13] While the mountain motifs are clearly in the Yen Wen-kuei tradition, their silhouetted forms are compressed together and pushed back in space, in the same way as those in *Wind-swept Stream*.

33 Market Village by the River

Handscroll on paper in the style of Yen
 Wen-kuei
About 1100
National Palace Museum, Taiwan

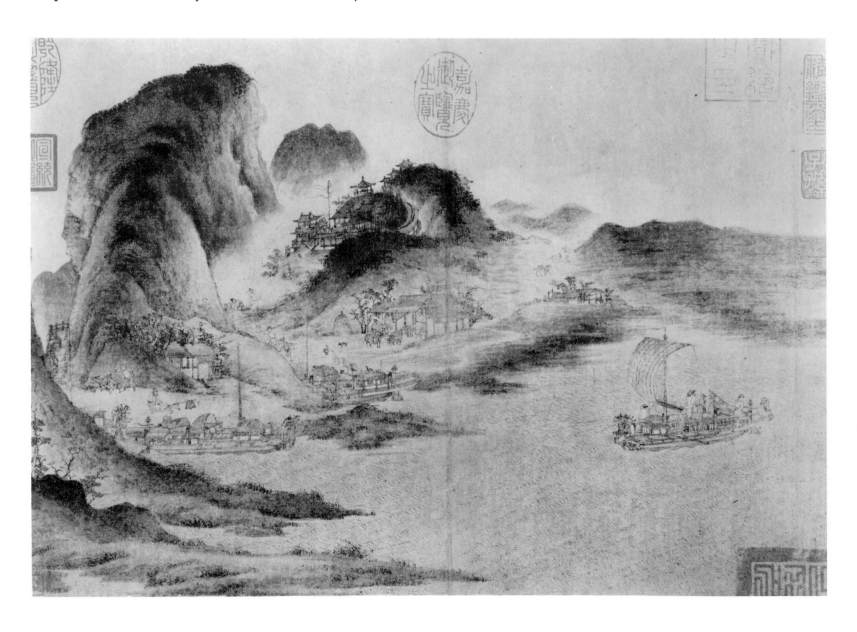

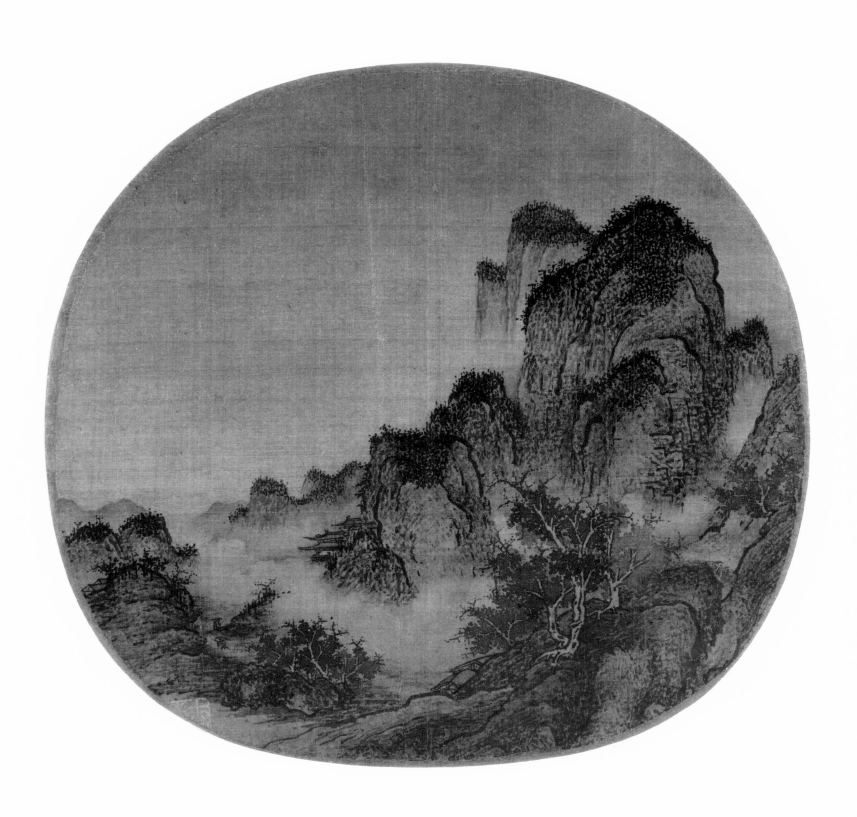

III

THE NORTHERN SUNG period ended in 1127 when the Chin tartars sacked the capital, Kaifeng. The survivors of this catastrophe fled south, across the Yangtze River, and established the Southern Sung court at Lin-an (modern Hangchow). In a landscape painted on a silk fan about 1150 (34), the Southern Sung viewer was offered a reminder of his lost northern homeland. The monumental forms of Fan K'uan are here adapted to an intimate format and a typical Southern Sung "one-corner" composition, and the Fan K'uan idiom is formulated into three types of brushstrokes: thickening and thinning contour strokes, stippled "raindrop" dots, and, on the mountaintops, foliage dots mixed with branch patterns (35). Though conventionalized, these brush patterns are successfully representational. This painting is a rare instance of a Southern Sung work in Fan K'uan's mode; most landscape painters of this time followed Li T'ang, and developed broader ink-wash styles with "ax-cut" texture strokes.

In the north, meanwhile, despite the destruction of the Northern Sung, the painting traditions of Yen Wen-kuei, Fan K'uan, and Kuo Hsi lived on. A scene in the handscroll painting *Streams*

34 *Landscape in the Style of Fan K'uan*

Painting on silk fan
About 1150
The Art Museum, Princeton University

35 Detail of 34

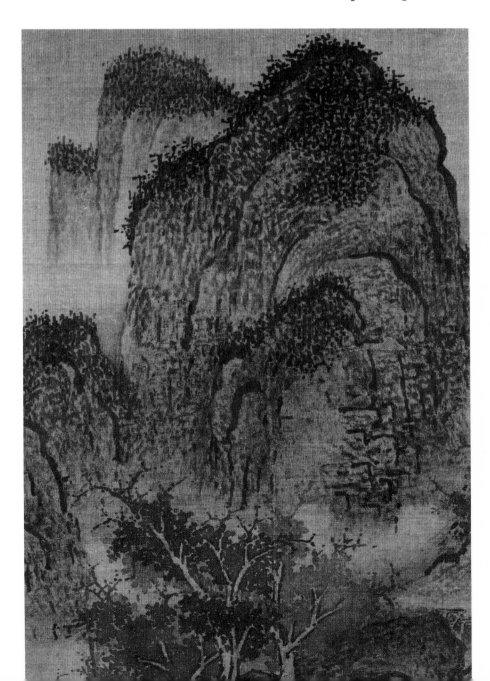

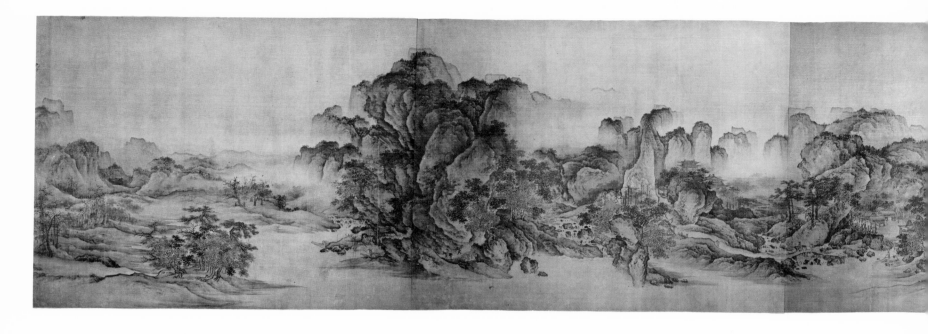

36 Streams and Mountains without End

Handscroll on silk
About 1150
Cleveland Museum of Art, Gift of Hanna Fund

37 Detail of 36

and Mountains without End (36) recalls a detail in Summer Mountains: a rider and a servant crossing a bridge on a path that leads to a temple complex nestled among the peaks (37). The mountain forms in this part of the scroll, clearly in the Yen Wen-kuei tradition, lead one to wonder if the painter had direct knowledge of Summer Mountains. Another point: the Northern Sung forms have been compressed and pushed farther back than even those in Wind-swept Stream; they have been "miniaturized" in the same way that Fan K'uan's forms were in the Southern Sung fan painting. This process of miniaturization has to do with the twelfth-century visual habit of seeing a landscape as a unified structure. The brushwork of the mountains and tree foliage in Streams and Mountains is broad and illusionistic, another sign of a mid-twelfth-century date. A further indication of such dating: at both ends of the scroll the "flat-distance" vistas begin to show convincingly articulated receding ground planes.[14]

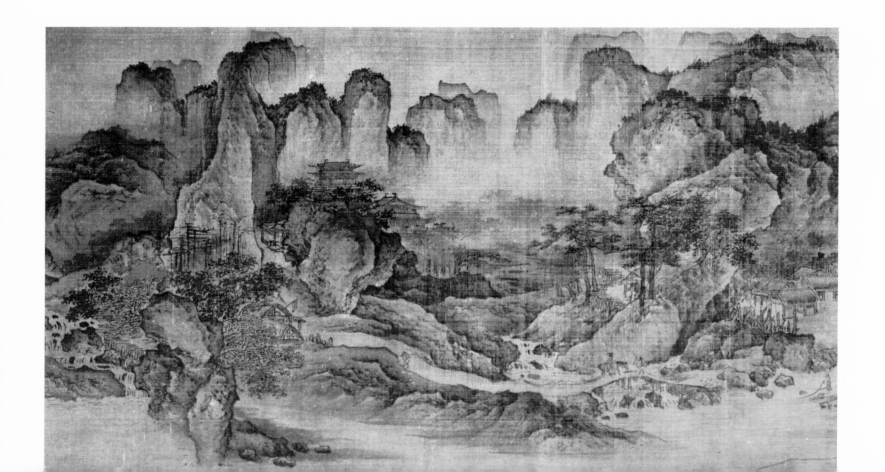

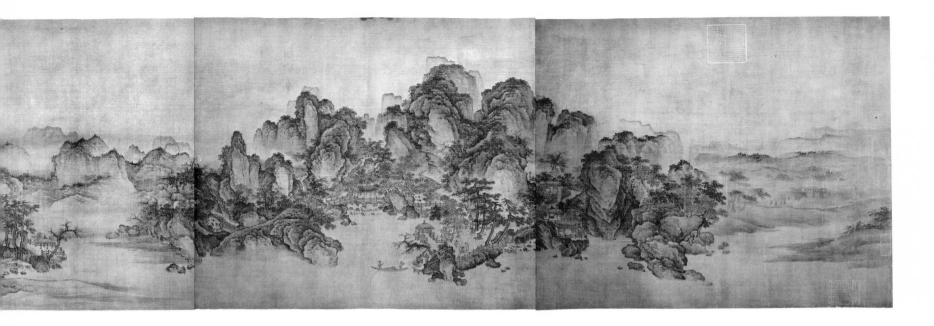

For the northern landscape style of the thirteenth century, one turns to a wall painting done about 1265, near Ta-t'ung in Shansi (38). Here, loose brushstrokes, applied with mixed ink tones, are deliberately fused and blurred to create variegated and illusionistic surfaces in the tree foliage and mountains. The mountain forms, a combination of those of Yen Wen-kuei and Fan K'uan, are now placed at an angle, with foreshortened shoulders and sides; the subsidiary peaks are clustered around, as well as behind, the central peak, and together they show a broad, three-dimensional base that sets into the terrain around them. Landscape forms are now integrated organic masses. With the help of foreshortening—especially in the trunks and branches—the painter is able to describe three-dimensional relationships between objects along a receding ground plane. Instead of being merely superimposed silhouettes, the forms of the vista to the right curve around in space and merge into forms behind them.

38 *Wall painting*

About 1265
Near Ta-t'ung, Shansi (Reproduced from
Wen-wu, 1960)

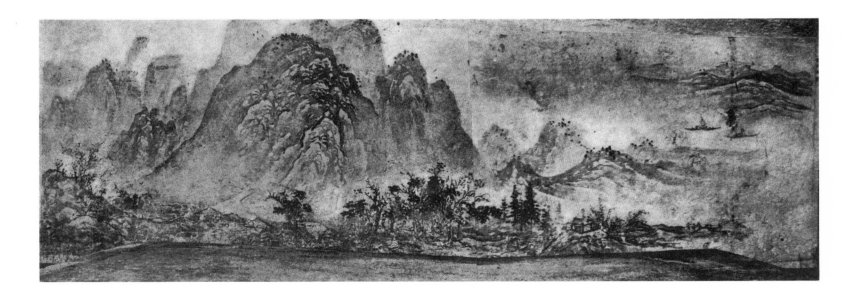

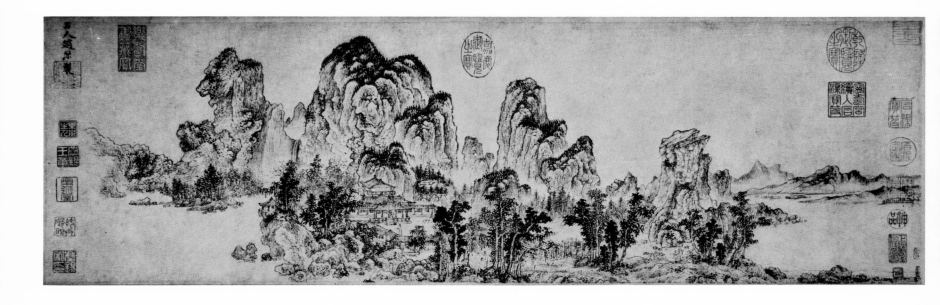

IV

39 *Landscape in the Style of Yen Wen-kuei and Fan K'uan*

Handscroll on paper by Chao Yüan
About 1370
The Art Museum, Princeton University

THE MONGOL (YÜAN) conquest of the Southern Sung in 1276 sent southern Chinese back to the north. In painting, as a result, there was a revival of Northern Sung landscape idioms. It was led by the calligrapher Chao Meng-fu (1254–1322), an exponent of the scholar-painter's aesthetic, which espoused a learned amateurism. Teaching that good painting should not only follow ancient models but also make use of calligraphic brush methods, Chao created a calligraphic landscape art that was entirely different from that of the Northern Sung.

A handscroll on paper by Chao Yüan (active about 1350–75), who lived in Soochow, shows the new landscape concept (39). Couched in the Northern Sung idioms of Yen Wen-kuei and Fan K'uan, it continues the structural advances seen in the Ta-t'ung wall painting. The mountain forms are conceived as organically integrated masses, trees in the back are seen through those in the front, and there is a properly foreshortened, receding ground plane—the distant mountains at the right show foreshortened shoulders that lead our eyes diagonally over and around the forms. But such technical advances in solving representational problems were no longer an important aesthetic concern for the Yüan scholar-painters, whose calligraphic-style brushwork, with ink wash largely eliminated, forcefully abnegated the notion that painting was representation of nature. Compare Chao Yüan's principal peak (40) with that of the Southern Sung fan. In both

cases, the painter uses a set of conventionalized brush formulas, but whereas in the fan, the brushstrokes are relaxed and subordinated to the representation, Chao Yüan's calligraphy-like strokes, each an independently assertive entity, have a life and quality of their own. Chao Yüan's landscape is written rather than painted.

In equating landscape painting with calligraphy, the scholar-painters saw painting as a vehicle for personal expression. Painting, it was said, should be like handwriting, a "heart print" of the artist. Technically, the calligraphic training enabled the later landscape painters to "imitate" ancient models and be creative at the same time. Limited to a set of series of brushstrokes, calligraphy bases its discipline on imitation: a beginner learns by following a model stroke by stroke, and as repetition brings him closer and closer to mastery of the form, he begins to express himself through the form. A calligraphic painter may repeat a familiar idiom or composition, but each result, just as in handwriting, can be different; at the same time, though he may work in a number of different idioms, he actually executes all of them in his own style.

This calligraphic technique enabled the painter to experience, beyond representation, a physical sense of nature's life energy through the act of painting. The final peak at the left of Chao Yüan's scroll, for instance, shows brushstrokes and dots revolving as if caught in a whirlwind, and becomes a visionary statement (41).

40 41 Details of 39

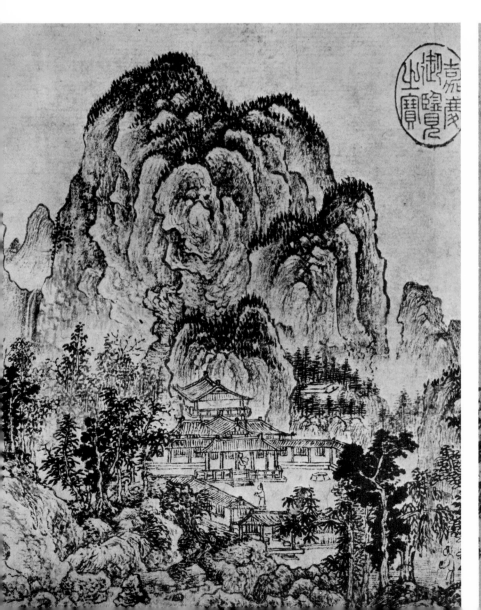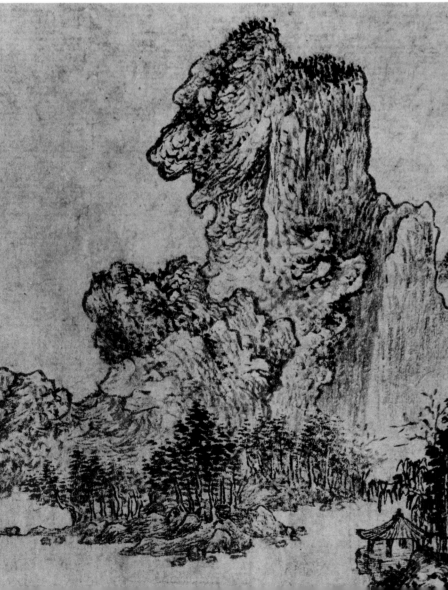

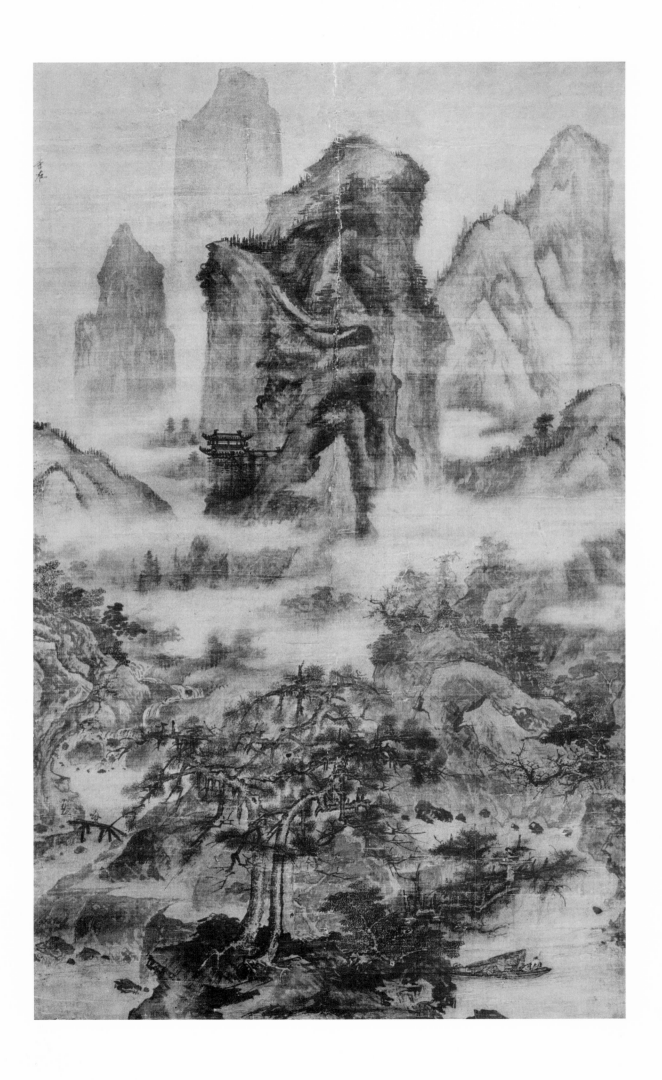

A second revival movement, which attempted a more literal reconstruction of Northern Sung styles, occurred in the early fifteenth century under the patronage of the Ming emperors, who, having overthrown the Mongols, saw themselves as legitimate heirs of the Sung. A hanging scroll by Li Tsai (42), a court painter in Peking during the reign of the emperor Hsüan-tsung (1426–35), returns to the grand manner of the Northern Sung. Comparing it with the final "high-distance" view at the left end of *Summer Mountains* (43), we discern the essential differences between the Sung and the Ming. In the eleventh-century painting the well-modeled forms are built up additively; similar motifs and shapes are repeated, either juxtaposed or superimposed, without being physically linked together. In Li Tsai's painting, the forms are illusionistically rendered with a complex brushwork that creates "wet" and intricate surfaces with many highlighting effects. A cross-shaped framework is introduced to bring the complicated

42 *Landscape in the Style of Kuo Hsi*

Hanging scroll on silk by Li Tsai
About 1430
Tokyo National Museum

43 Detail of 13

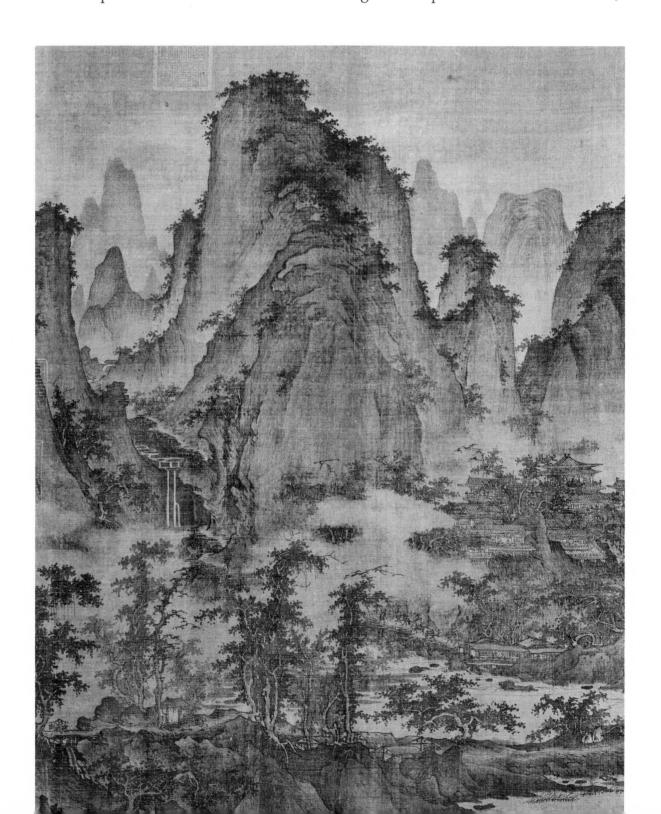

details into order: the central peak and foreground pine trees now act as a vertical axis, with bands of mist running horizontally across it. The result is that all the elements are held together rigidly and statically; they become surface-conscious and patternistic, as in a tapestry design. One could imagine that if a peak or a tree were suddenly removed from *Summer Mountains*, a natural void would reclaim the space. In Li Tsai's work, the removal of any part would result in a hole in the surface.

Technically, Li Tsai's virtuoso brushwork (44) is very different from Chao Yüan's. While the scholar-painter's calligraphy-like strokes—done with the point of the brush centered inside the stroke—are round and assertive, each possessing an independent expressive quality, the professional painter's more descriptive brushwork—flat, "ax-cut" shapes made with the brush held at an angle—is subordinated to the representational form. This difference in technique, coupled with the scholar's preference for paper and the professional's preference for silk, reflects a basic divergence in approaches to painting. Whereas the scholar viewed painting as a form of self-expression, the professional created impressive visual designs. From the scholar-painter's point of view the professional captured only "likeness," not "truth," whether he was representing nature or following ancient models. One result of this attitude was that the early Ming court paintings were neglected by later collectors under the influence of the scholar-painter's aesthetic. Paradoxically, many of them were treasured as Sung paintings when they were misrepresented with false attributions added by dishonest dealers.

In a hanging scroll, *Pavilions by Rivers and Mountains* (45), attributed to Yen Wen-kuei but painted much later, we find mountain forms, brush technique, and architectural details bearing considerable resemblance to those seen in Yen's large handscroll of the same title (9). Yet the drawing of the hanging scroll is not only stiff and mechanical, it also shows a general insensitivity to

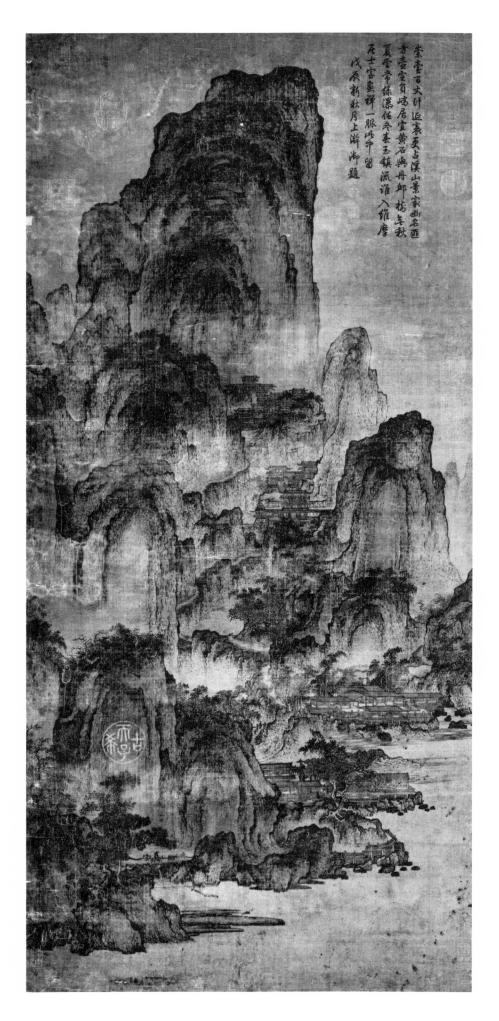

蒙雪百尺汗近衰更占溪山景家幽名區
方壺寶頁峪居宣黄石與舟邱坊冬秋
夏雲亭徐溪住矣秉玉鎮流誰入維摩
石士室畫祥一脈岈中留
戊辰新秋月上瀚御題

45 *Pavilions by Rivers
and Mountains*

Hanging scroll on silk attributed to Yen
 Wen-kuei
About 1430
National Palace Museum, Taiwan

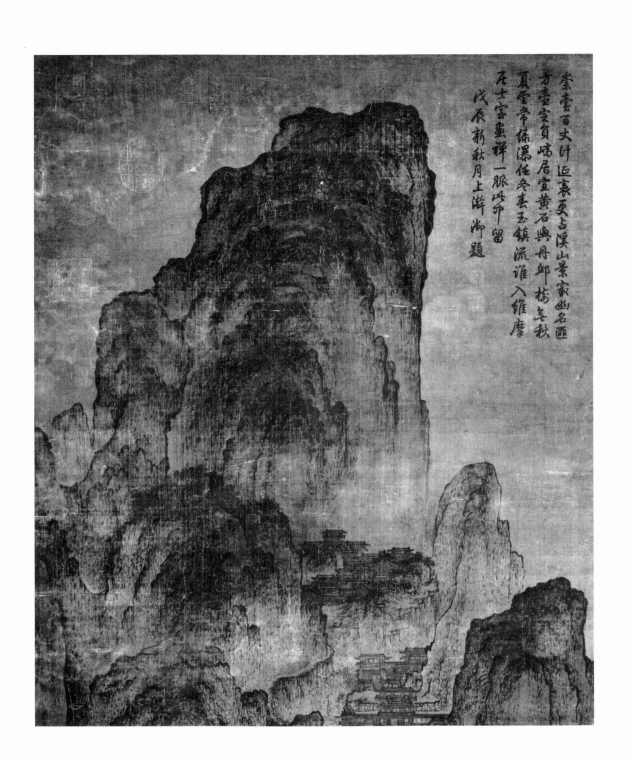

棠臺百丈枕迤裏更占溪山景象幽名巵
方壺寶貞崎居宜黃石興丹邱橋等秋
夏雲常練瀑任冬春玉鎮流谁入維摩
石士宮壺禪一脉以邧留
戊辰新秋月上游御題

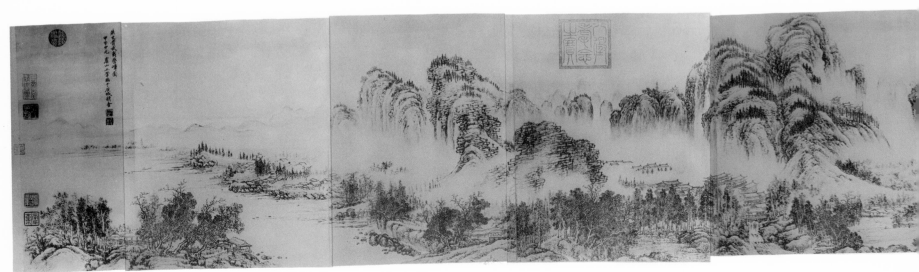

Northern Sung forms. The individual thickening and thinning contour lines on the central peak, for instance, no longer describe the rocky mountain forms; they are arbitrary and playful brushstrokes that hang loosely on the surface like limp worms (46). Compositionally, certain passages in the mid-area of the rising mountain--a web of curvy lines—seem unintelligible. In spite of the stacked-up frontal mountain motifs, which suggest that the painting was possibly based on a lost work by Yen, the compositional structure is surface-conscious and patternistic. The painting seems to be a copy, probably made no earlier than Li Tsai's time, or about 1430.

The third and final revival of Northern Sung styles took place in the late seventeenth and early eighteenth centuries, when Wang Hui (1632–1717), the leading master of the so-called Orthodox School, produced a synthesis of all the ancient styles. About his art Wang Hui wrote: "I must use the brush and ink of the Yüan to move the peaks and valleys of the Sung. . . . I will then have a work of the Great Synthesis."[15]

Beginning in the early 1680s, and continuing for more than thirty years until the end of his life, Wang showed a special fascination for Yen Wen-kuei. His successive experiments in Yen's style, representing his efforts in "moving the peaks and valleys of the Sung" with calligraphy-like brushstrokes, meant not only the recapturing of monumentality, but also a new reconciling of abstract brush idioms with the painter's desire for describing real scenery. On one enormous handscroll, *Multiple Peaks along Many Rivers*, measuring more than sixty feet in length, he wrote an inscription describing how during a summer's visit to the Ch'in-huai River, he was so moved by the scenery that he spent three whole months painting it, using a combination of three Northern Sung idioms, those of Chü-jan, Yen Wen-kuei, and Fan K'uan.

Another handscroll by Wang, dated the same year, 1684 (47), is based on a composition by Yen; many of its motifs may be com-

47 Landscape after
Yen Wen-kuei's Multiple
Peaks of Mount Wu-yi

Handscroll on paper by Wang Hui
Dated 1684
Reproduced from an old reproduction

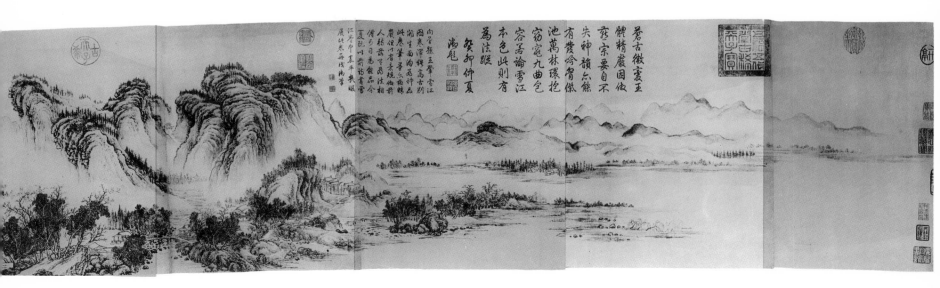

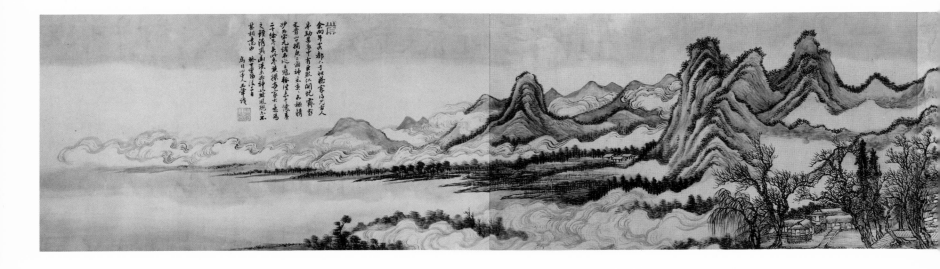

48 *Landscape in the Style of Chü-jan and Yen Wen-kuei*

(left half)

Handscroll on paper by Wang Hui
Dated 1713
Earl Morse collection, New York

pared with those in *Summer Mountains*. Wang continued to explore the Yen Wen-kuei theme in three handscroll compositions dated 1711, 1712, and 1713. The last of these (48) shows his final style: powerful brushwork with an almost careless, yet sure, touch. The last portion of the scroll—the left end, that is—is particularly successful in recapturing Yen Wen-kuei's manner in its rhythmically undulating mountain silhouettes and cloud scrolls (49).

In Wang Hui's work, painting has become, like calligraphy, a matter of orchestrating lines and forms in abstract space. A younger contemporary of Wang's, Wang Yüan-ch'i (1642–1715), explained that, in painting,

> one needs to pay attention only to the "breath force" and the general outline of the design. It is not necessary to represent beautiful scenery, nor is it important to follow old compositions. If one knows how to open and close, rise and fall, whenever the veins and connections turn or halt, wonderful scenery will naturally appear.[16]

If Wang Hui saw the Yen Wen-kuei idiom as a key to his reconstruction of a monumental landscape style, it was only because he had succeeded in discovering Yen's style and reformulating it through his own. Yet in recalling the Yen Wen-kuei tradition, Wang's creation of 1713 follows its own structure, its own technical and aesthetic considerations. It is anything but a counterfeit of the older master's style.

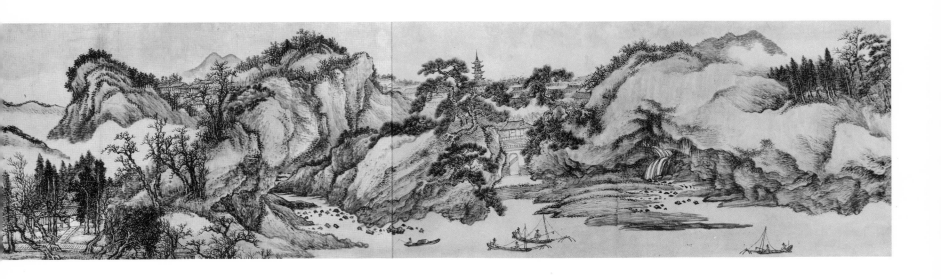

49 Detail of 48

Notes

1. *Summer Mountains* is fully described in Wen Fong, Marilyn Fu, *Sung and Yuan Paintings*, The Metropolitan Museum of Art, 1973, pp. 17–25, 138.

2. Huang Hsiu-fu, *I-chou ming-hua lu* (before 1006), reprint in *Hua-shih ts'ung-shu*, Shanghai, 1959, p. 21.

3. Reprint in *Chung-kuo hua-lun lei-pen*, edited by Yü Chien-hua, Peking, 1956. For the latest annotated translation of Ching Hao's text, see Kiyohiko Munakata, *Ching Hao's Pi-fa-chi: A Note on the Art of Brush*, Ascona, 1975.

4. Wai-kam Ho, "Li Ch'eng and the Mainstream of Northern Sung Painting," *Proceedings of the International Symposium on Chinese Painting*, Taipei, 1972, pp. 251–282.

5. The earliest biographical mentions of Yen Wen-kuei are found in Kuo Jo-hsü's *T'u-hua chien-wen chih* (about 1080), and Liu Tao-ch'un's *Sheng-ch'ao ming-hua p'ing* of about the same time; see Alexander C. Soper, *Kuo Jo-hsü's Experiences in Painting*, Washington, D.C., 1951, p. 58, note 504.

6. *Hsüan-ho hua-p'u* (compiled before 1120), reprint in *Hua-shih ts'ung-shu*, Shanghai, 1959, p. 117.

7. *Sung and Yuan Paintings*, pp. 24–25.

8. See Weng T'ung-wen, "An Investigation on Dates of Some Painters, Part II," *National Palace Museum Quarterly*, IV/3, January 1970, p. 45.

9. *Kuo Jo-hsü's Experiences in Painting*, p. 58.

10. English translations by Shio Sakanishi, *An Essay on Landscape Painting*, London, 1935, and Osvald Sirén, *Chinese Painting: Leading Masters and Principles*, London, 1956, I, pp. 220–230.

11. Among other works attributed to Kuo Hsi, a handscroll in the John M. Crawford collection, New York, *Colors of Trees on a Level Plain*, compares closely with the brushwork and forms of *Early Spring*. This is the only work in a Western collection that can be firmly attributed to Kuo's hand.

12. In addition to *Clearing Autumn Sky over Streams and Mountains*, a hanging scroll by Li Kung-nien in The Art Museum, Princeton University, and a handscroll attributed to Hsü Tao-ning, *Temple in Autumn Mountains*, in the Fuji-Yurinkan, Kyoto, both of which may be dated around 1100.

13. Both the boats and camels recall similar details in Chang Tse-tuan's *Ch'ing-ming Festival on the River*, in Peking, which also depicts a Kaifeng river scene in the late Northern Sung period.

14. In Sherman E. Lee and Wen Fong, *Streams and Mountains Without End*, Ascona, 1955, this painting was dated to the first quarter of the twelfth century, at the end of the Northern Sung period. Part of the reason for this dating was documentary: while the earliest colophons now on the paintings are dated 1205, during the Chin period, two of its fourteenth-century colophons mention "colophons of three dynasties, Sung, Chin, and Yüan." If these references to "Sung" colophons were merely figurative, the painting could have been done any time before the first colophon of 1205.

15. Wen Fong, "The Orthodox Master," *Art News Annual* XXXIII, 1967, pp. 133–139.

16. Roderick Whitfield, with an addendum by Wen Fong, *In Pursuit of Antiquity*, Princeton, 1969, p. 184.

SUMMER MOUNTAINS

A *painter is a sage. He rounds out where heaven and earth leave off, and reveals that upon which the sun and the moon do not shine. Where he wields his fine-hair painting brush, ten thousand things follow the command of his heart; through what his bosom holds, a thousand miles [of scenery] lie within his palm.*

Chu Ching-hsüan
historian of art, ninth century

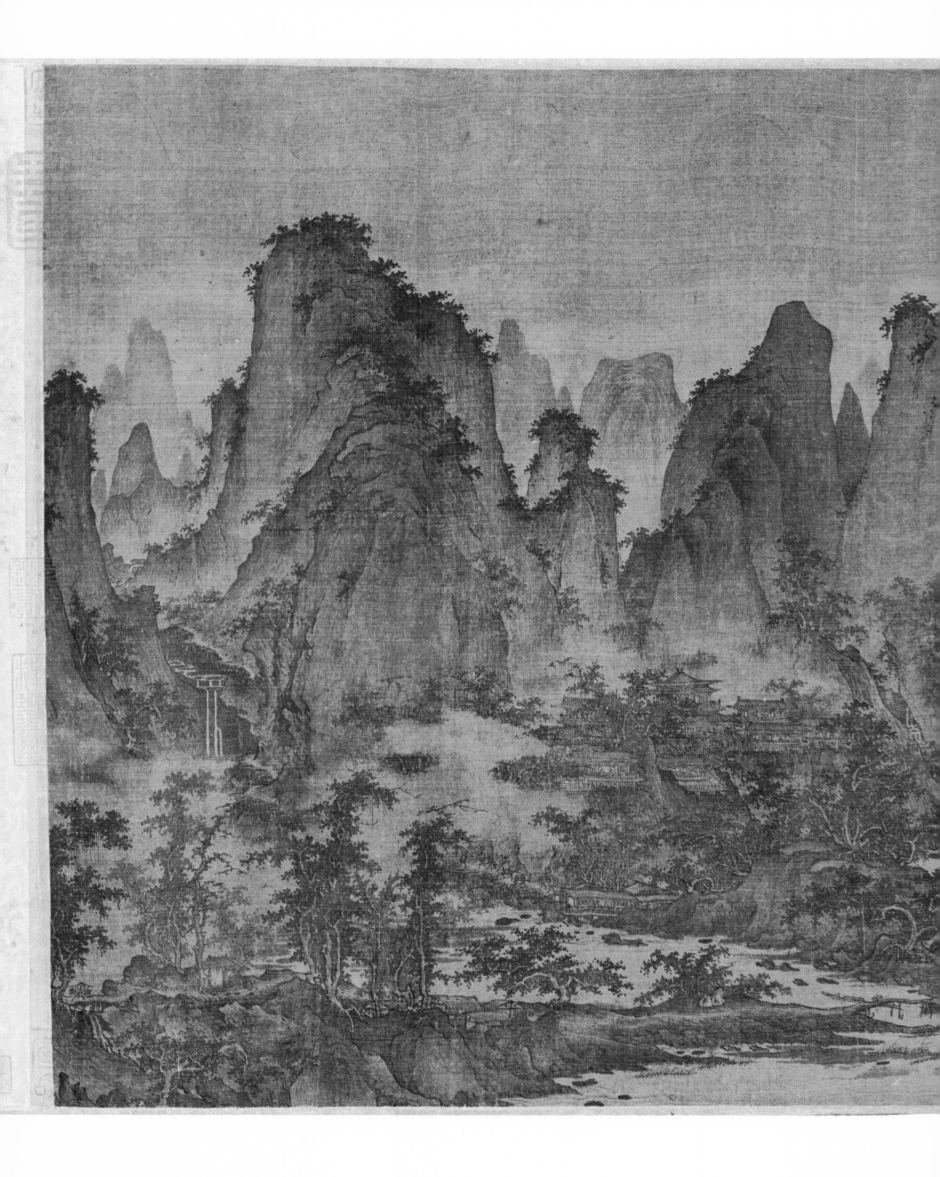

The evening peaks are green, the tree tops are red,
River boats and fishing nets are reflected in the water;
I remember that once in the south,
I saw a screen painting by Chü-jan that looks like this.

Lin Pu

(967–1028), hermit

The clouds and vapors of a true landscape are not the same throughout the four seasons. In spring they are bright and harmonious, in summer dense and brooding, in autumn scattered and thin, in winter dark and gloomy. . . . The mist and haze of a true landscape are not the same either throughout the four seasons: the spring mountains are tranquil and captivating as if smiling; the summer mountains are deep and green as if dripping with dew; the autumn mountains are clear and neat, like a woman freshly made up; the winter mountains are melancholy and still as if sleeping. . . .

In spring mountains, mist and clouds seem languorous and people are joyful; in summer mountains, the great trees are luxuriant and shady and people are relaxed; in autumn mountains, which are clear and pure, with leaves falling, people are solemn; in winter mountains, which are covered with dark clouds, people are forlorn.

Kuo Hsi

(active about 1050–90), painter and theorist

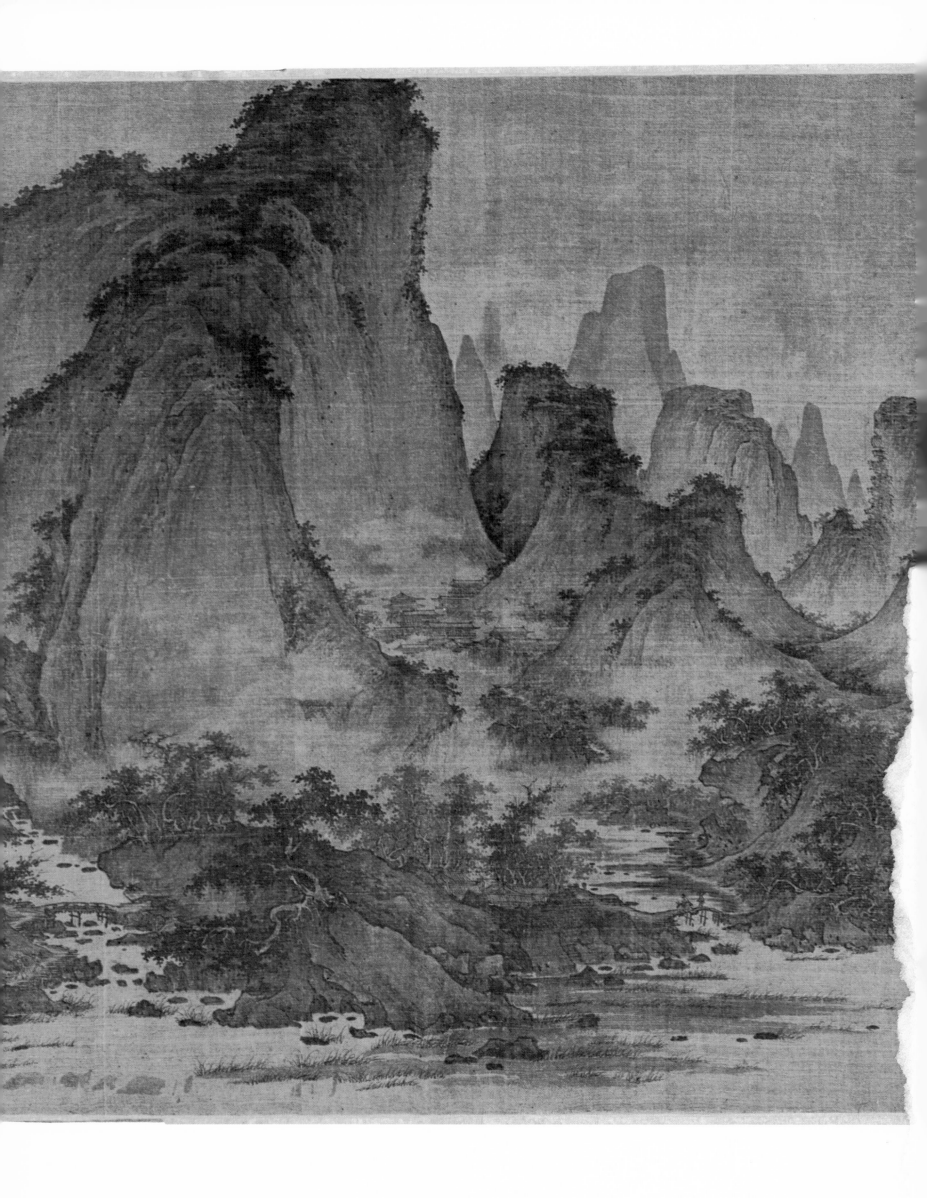

古秀芸芳歲月
多鍚題弥重玩
宣和印看與物
開生面渾是眈
池寫擘窠如滴
夏山常畧畧欲
嗚晴峽漸悍波
高樓百尺軒而
敞試一憑欄快
名何
戊辰新正月
御題

Now the Yin and the Yang fashion and form all things. . . . Grasses and trees may display their glory without the use of reds and greens; clouds and snow may swirl and float aloft without the use of white color; mountains may show greenness without the use of blues and greens; and a phoenix may look colorful without the use of the five colors. For this reason a painter may use ink alone and yet all five colors may seem present in his painting.

Chang Yen-yüan
historian of art, ninth century

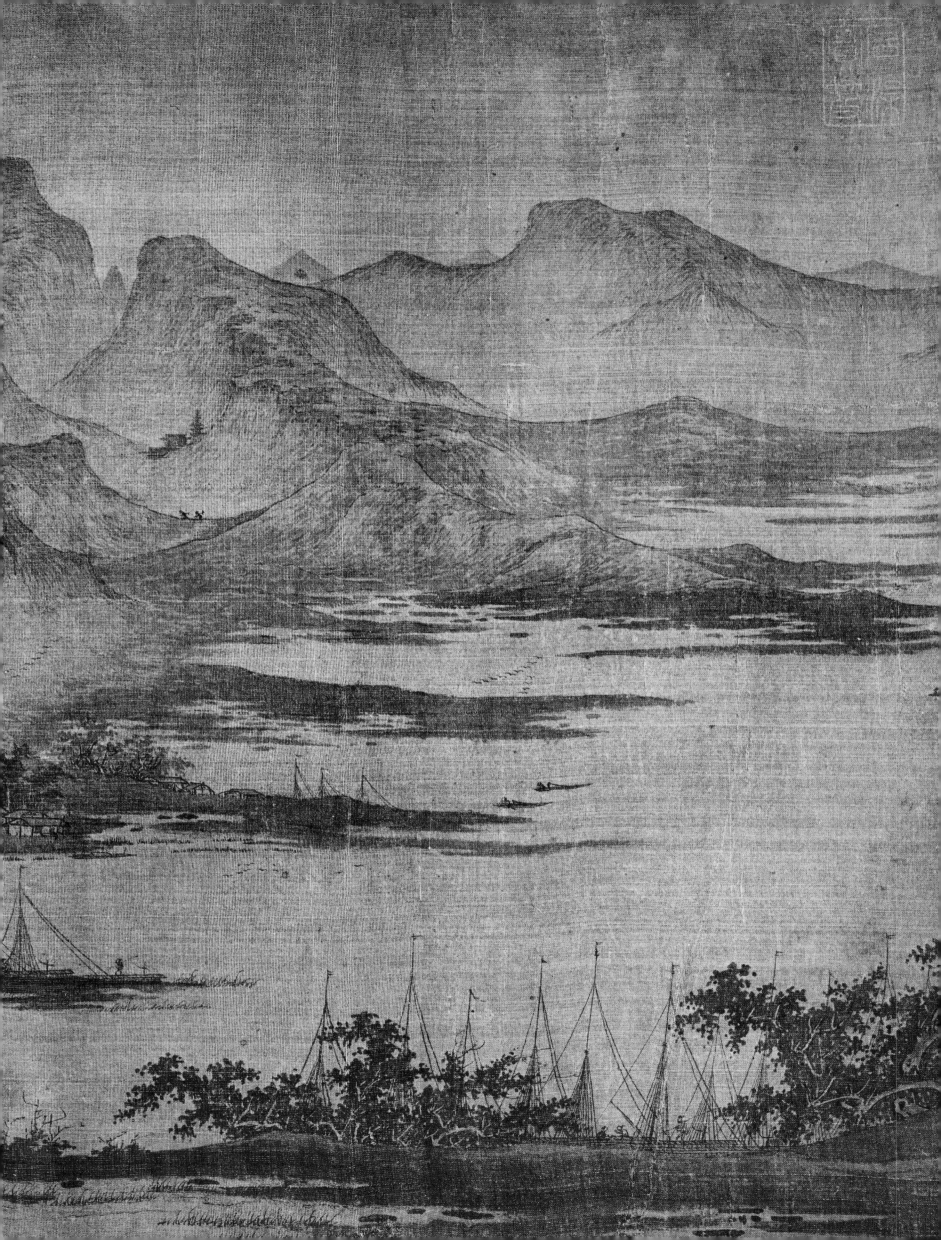

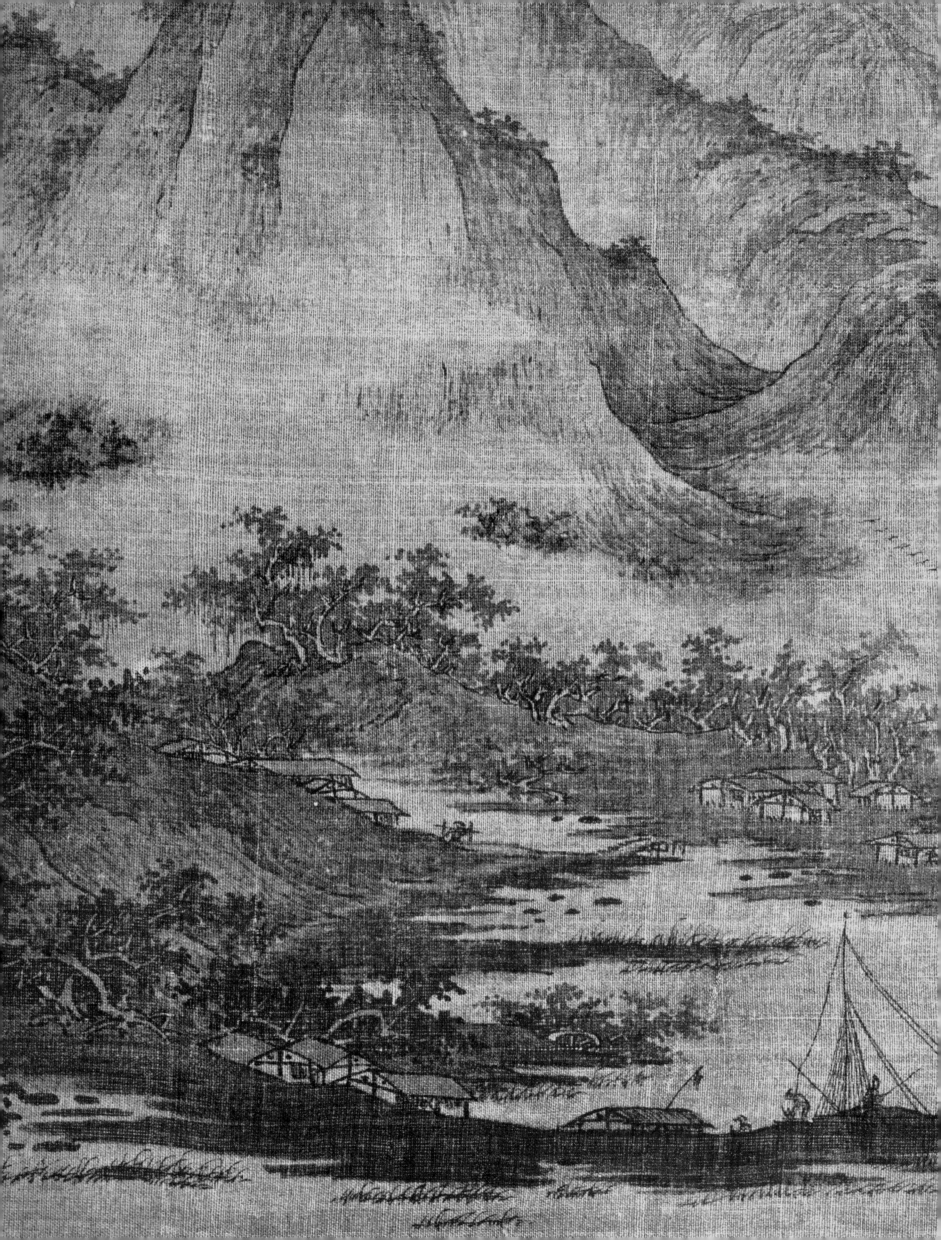

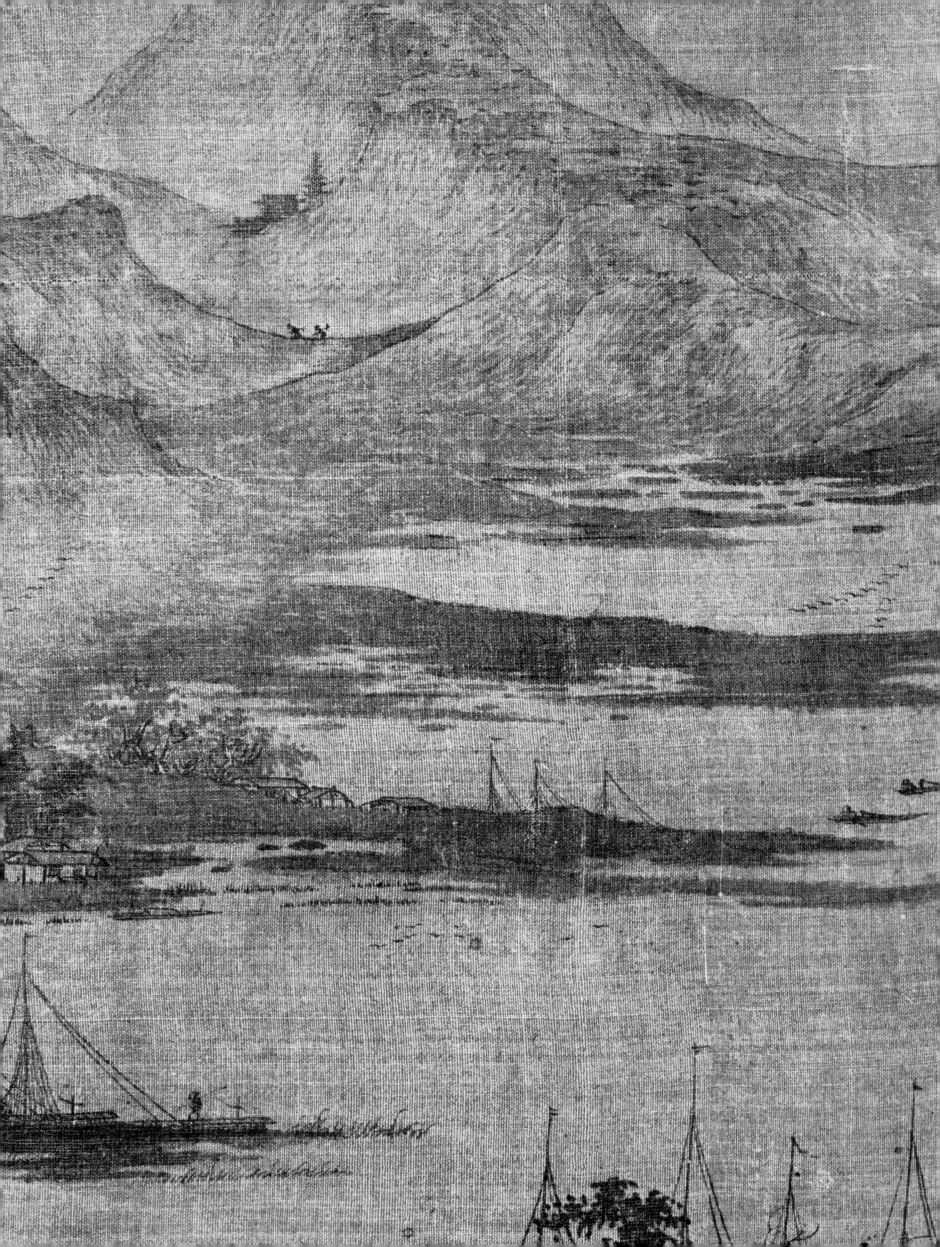

From afar I love this summer scene,
Mile after mile a feeling of pure exhilaration stays with me;
After a long winding stream,
We now come to a broad ravine,
An ancient monastery is hidden amid bamboos,
Its fragrant pavilions are spread out among the twisting cliffs.
The clouds and mists glow in the clearing sky after rain,
Both grasses and trees show a tender new green;
The season's birds are chirping away,
And the mountain flowers compete in riotous colors;
The long journey home does not trouble me,
As the bright moon shall keep me company.

Mei Yao-ch'en

(1002–1060), poet

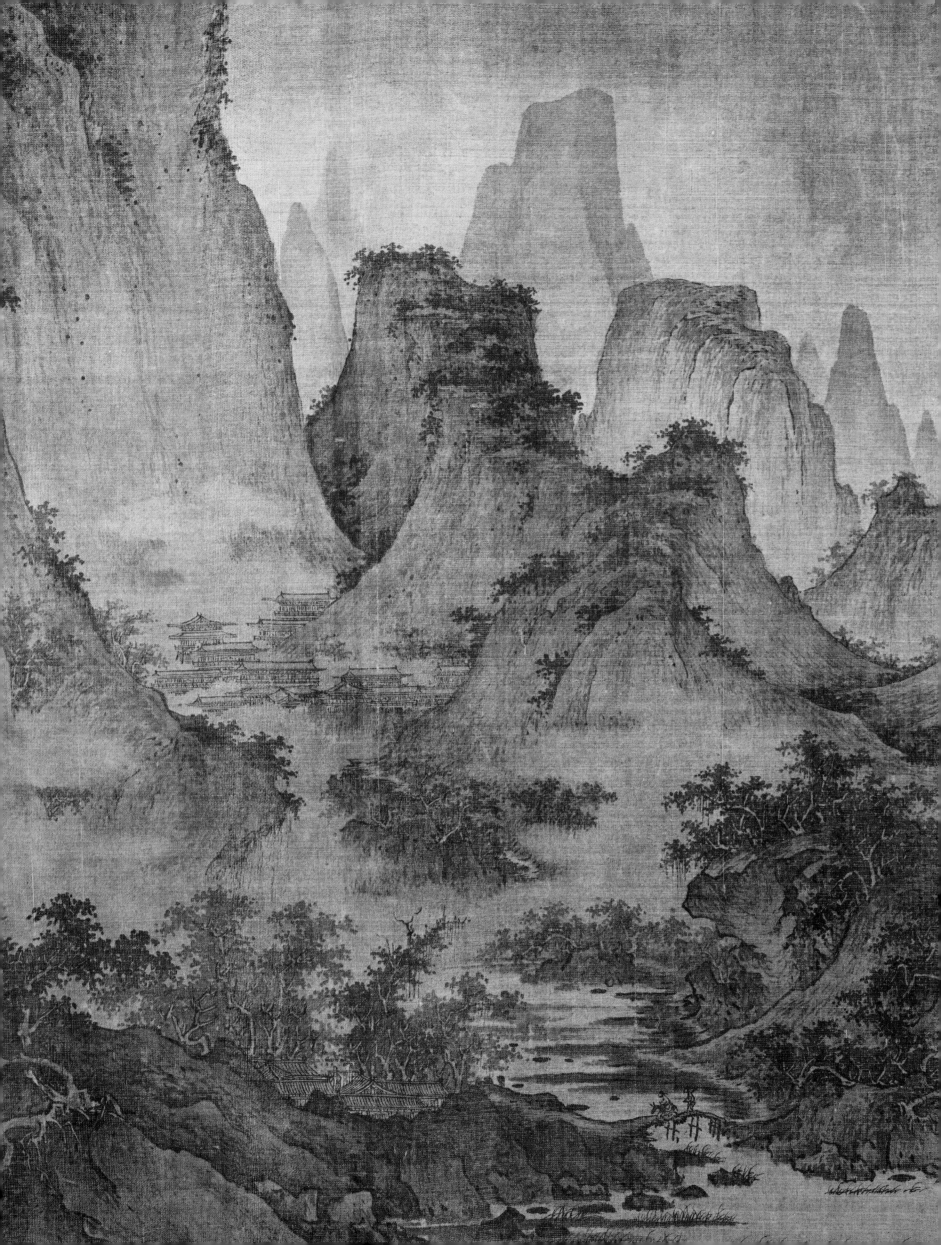

A great mountain is stately; it is the lord of all the mountains. Thus all the hills and slopes, forests and valleys, should be arranged around it; it is the chief of everything far and near, large and small. Its appearance is that of an emperor sitting majestically in his glory, receiving the courting of his subjects, but without showing any sign of arrogance.

Kuo Hsi

It has been said that there are landscapes one can walk through, landscapes which can be gazed upon, landscapes in which one may ramble, and landscapes in which one may dwell. . . . Those fit for walking through or being gazed upon are not equal to those in which one may dwell or ramble.

Kuo Hsi

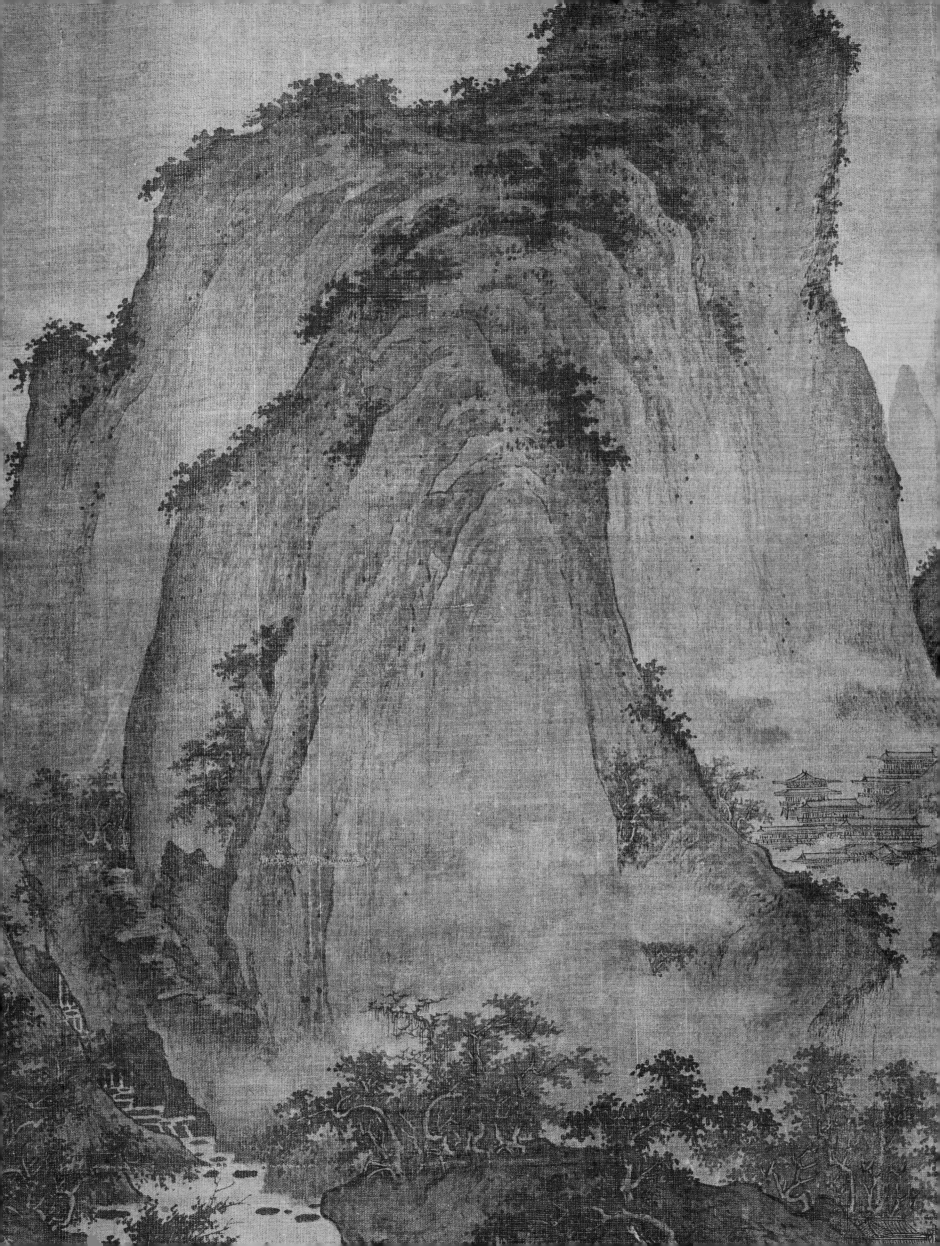

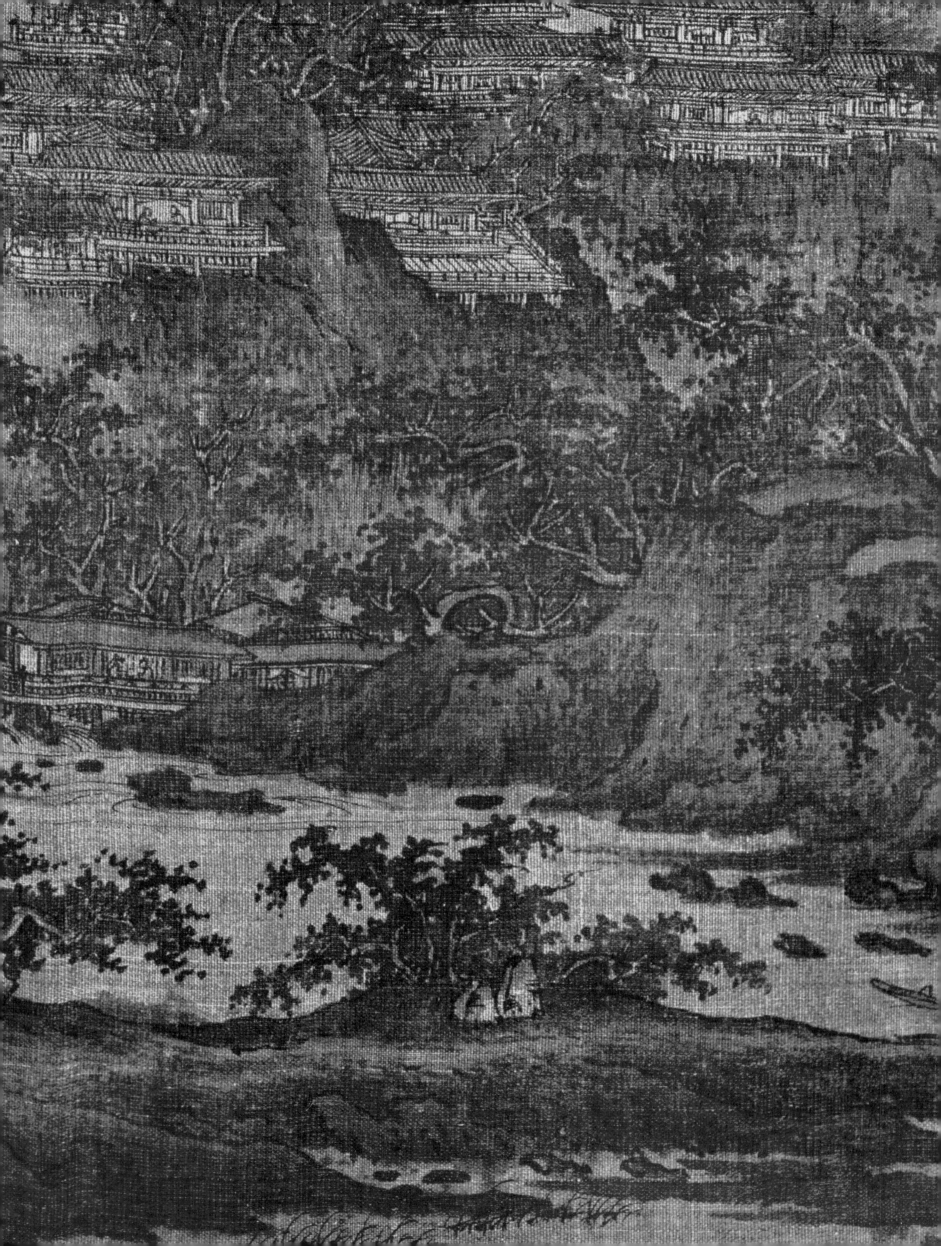

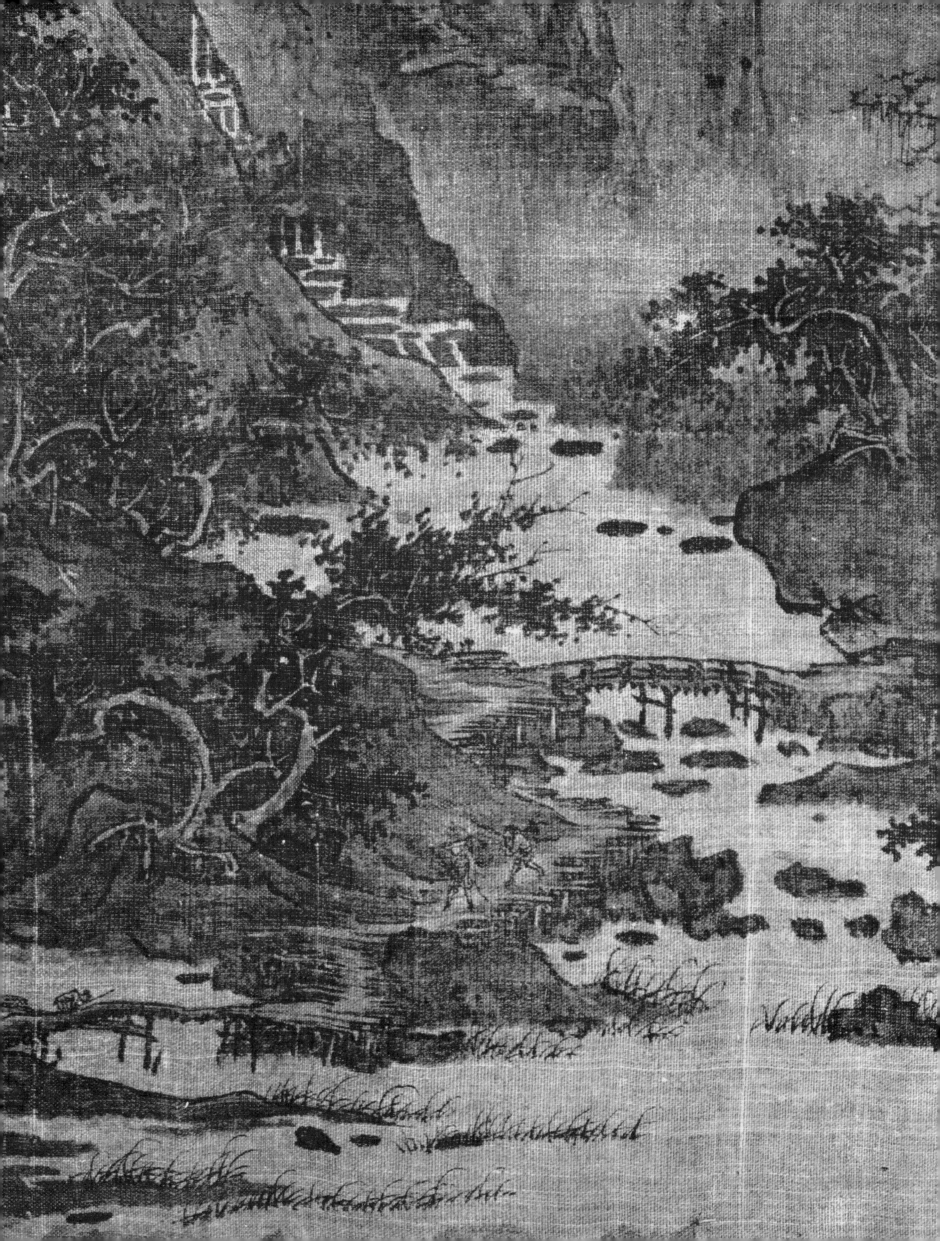

"Forty is not old,"
So I, the Old Drunkard, write in a poem;
In drunkenness I forget everything,
Then why should I remember my own age?
I love this water flowing under the pavilion,
It comes from between the wild peaks,
It sounds as if it fell from the sky,
Or like rain pouring down on my front eaves;
It runs into the stream under the cliffs,
Where a quiet spring adds to its rippling surface,
The sound it makes does not interfere with our conversation,
It is pure and is unlike pipe or string music,
It is not that I dislike strings and pipes,
But strings and pipes are too noisy.
I would come here often with some wine,
To walk along the gurgling waters;
The wild birds will watch me get drunk,
And the streams and clouds will ask me to stay the night;
Yet the mountain flowers can only smile to me,
They do not know how to speak;
Only the wind, coming through the gap,
Blows on me, and I awake.

Ou-yang Hsiu
("The Old Drunkard") (1007–1072),
statesman and historian

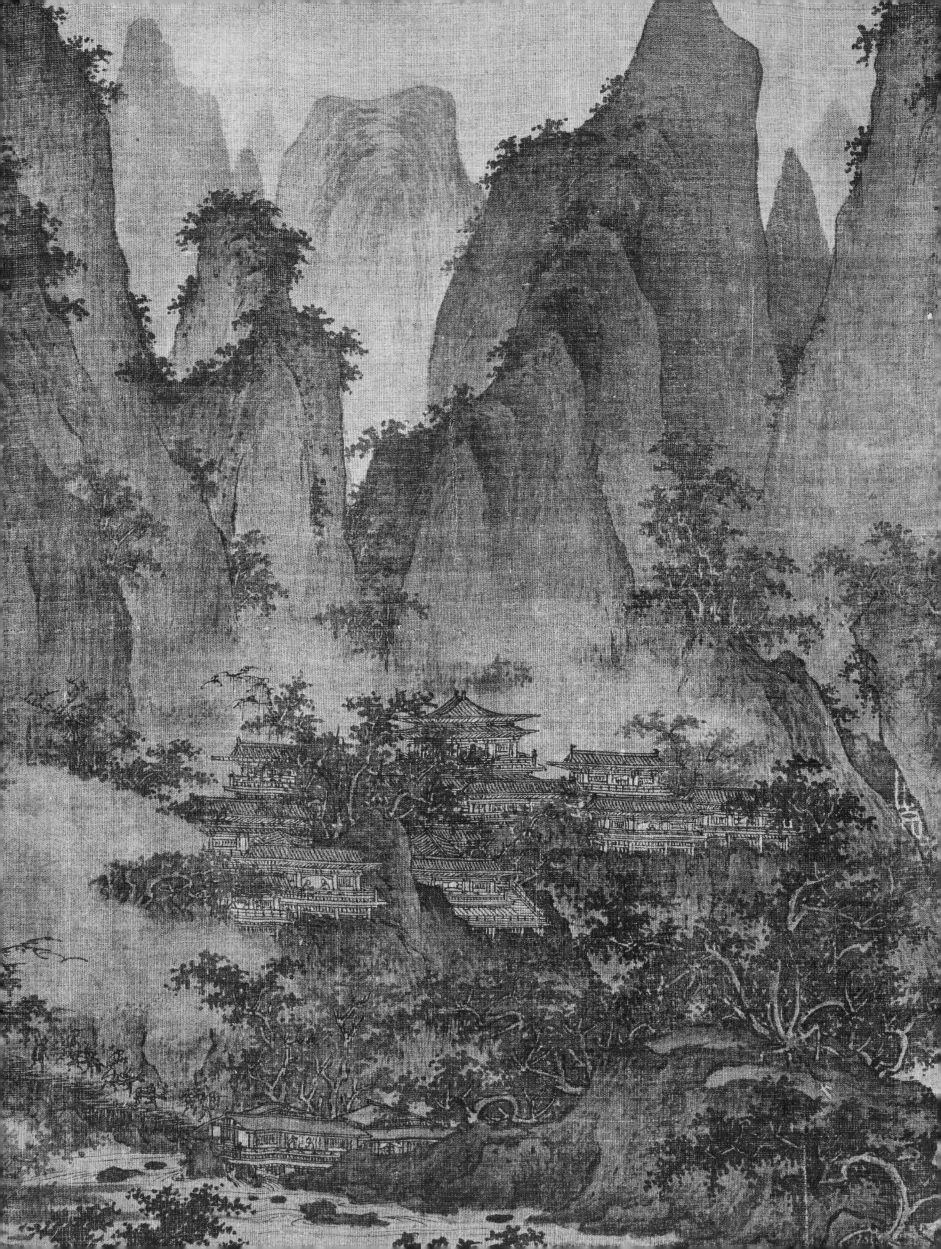

This mountain is truly quiet,
On the shaded cliffs the moss is thick and green;
Waters and stones need not be many,
They evoke the feeling of a thousand cliffs,
Though this place is not far from people,
Morning and night the air is excellent;
Shadows in the pool move with a gentle breeze,
The light in the forest reflects a newly clear sky;
With hands under my chin, I lie on the fragrant grass,
It is easy to set aside all worldly concerns.
Since I am not yet retired from life,
This is my place of restful retreat.

Hsü Hsüan

(916–991), scholar and editor

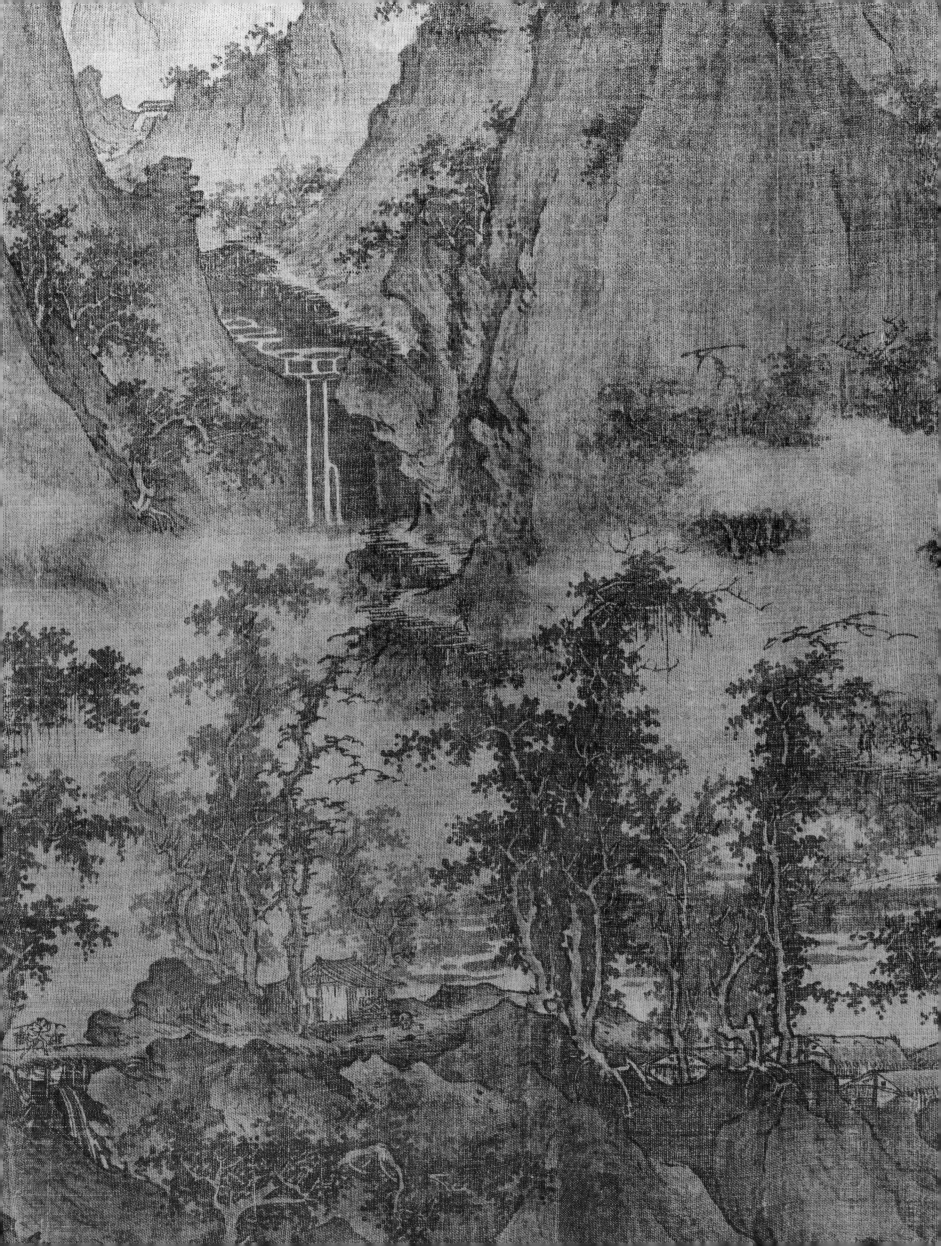

There are various ways of painting landscapes . . . also different ways of looking at landscapes. If we approach them with the heart of forests and streams, their value is high; but if we approach them with the eyes of pride and extravagance, their value is low. . . .

We yearn for forests and streams because they are beautiful places. A painter should create with this thought in mind, and a beholder should study a painting with this thought in mind.

Kuo Hsi

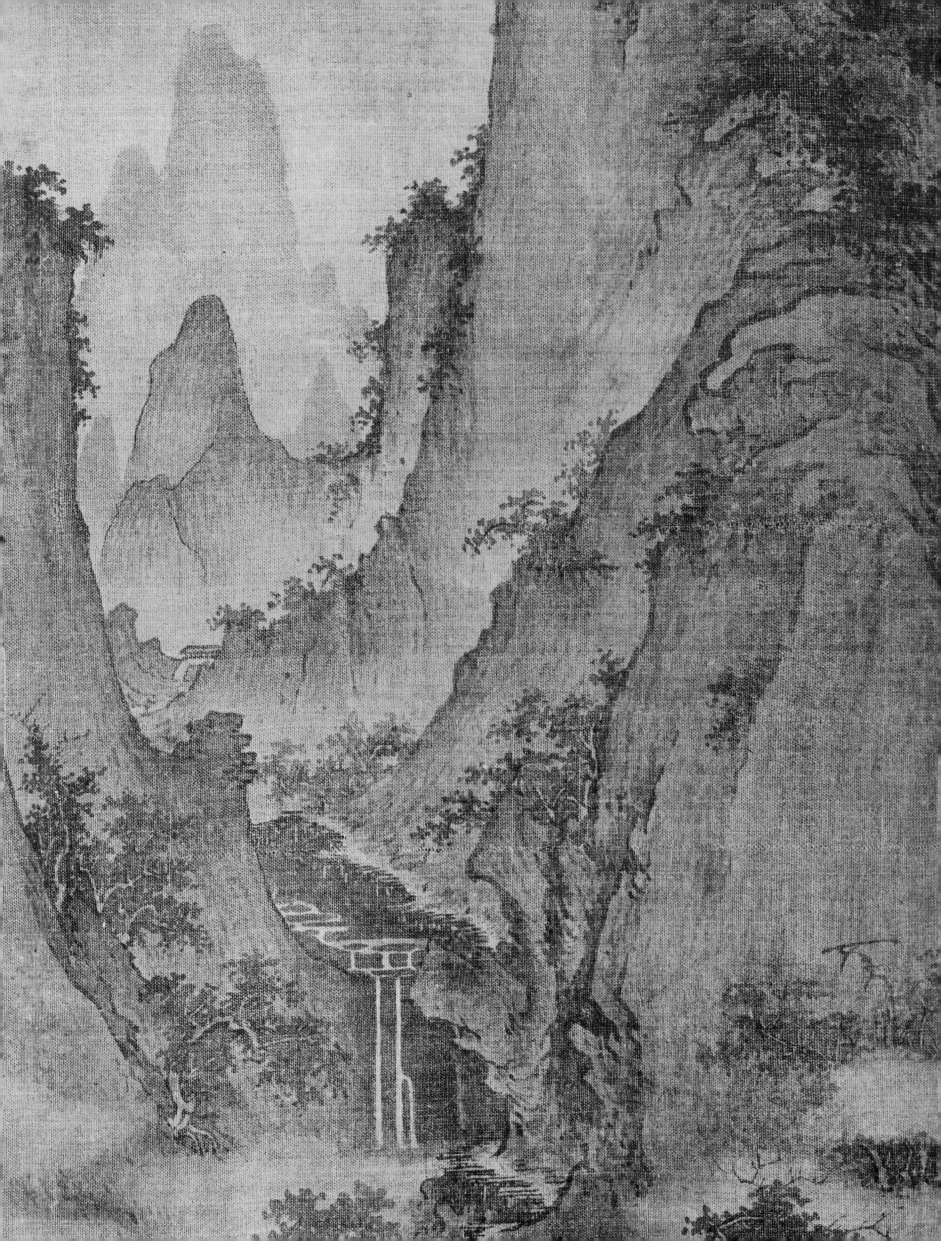

Design by Peter Oldenburg
Composition by Finn Typographic Service
Map by Joseph Ascherl
Foldout reproduction of *Summer Mountains* by Colorcraft Offset
Printed by The Meriden Gravure Company
Bound by Robert Burlen & Son